ROUGHNECKS

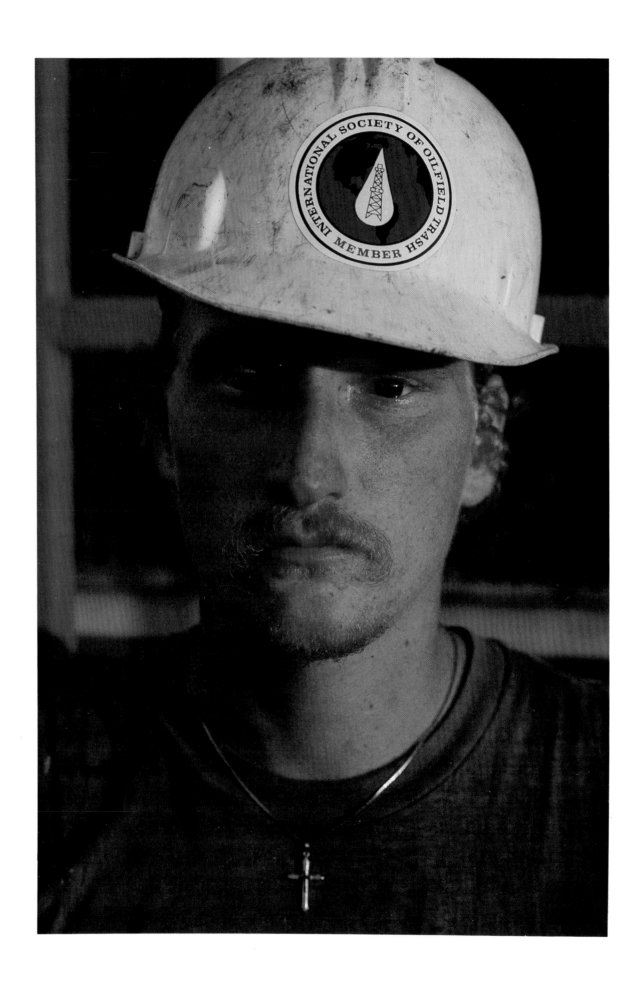

ROUGHNECKS

OIL PATCH U.S.A.

PHOTOGRAPHS AND
INTERVIEWS BY

KIT KITTLE

TAYLOR PUBLISHING COMPANY
DALLAS, TEXAS

BOOK DESIGN BY

**LAURETTE RANDALL
ANGSTEN THROPP**

Copyright © 1985 by Kit Kittle

Library of Congress Cataloging-in-Publication Data

Kittle, Kit
 Roughnecks: Oil Patch, U.S.A.

 1. Oil well drilling—United States—Pictorial
works. I. Title.
TN872.A5K58 1985 779′.96223382 85-25016
ISBN 0-87833-466-1

Printed in the United States of America

0 9 8 7 6 5 4 3 2 1

For My Parents

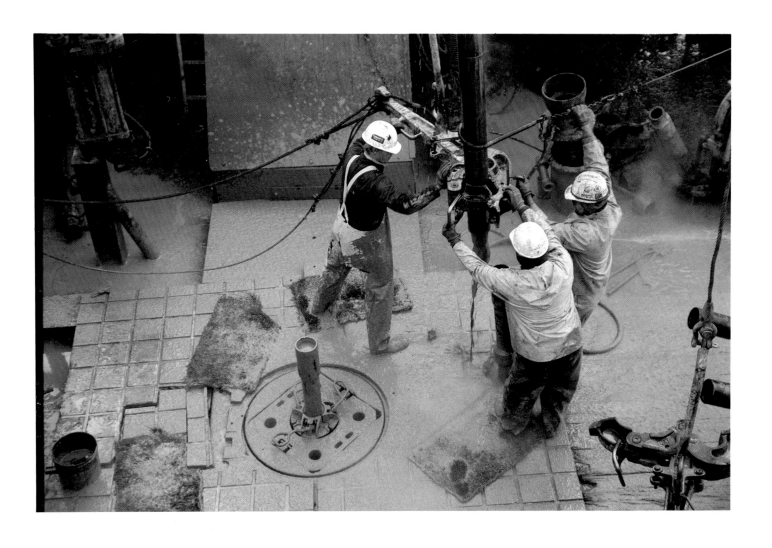

CONTENTS

INTRODUCTION

*You may be called a drunken dog by some of
the high collar and silk stocking gentry, but the real
roughnecks will style you a jovial fellow.*

Davey Crockett in the year of the Alamo

After a month reading about the oilfield, writing letters to oil companies, and talking on the phone, I still didn't know much about roughnecks or where exactly to go. I remembered that my mother had made a point of telling me when I was little not to run with roughnecks or I'd get to be just like one. She didn't specifically mean the roughnecks that work on oil drilling rigs any more than Davey Crockett did in the Texas of 1836; but looking back now, they both had the right idea.

Like cowboys, frontiersmen, and gold-rushers, roughnecks are an American archetype. They are free and brave. They practice all the vices admired by American manhood and none of the virtues we dislike. Roughnecks are boisterous. They roughhouse. They live with danger and move with gumption. A woman in Louisiana said, "I can pick out a roughneck just walking down the street 'cause they always look so ready."

Roughnecks work close to the source of American wealth both physically and in spirit. More than two-and-a-half million oil wells have been drilled in the United States, four times as many as all the rest of the world combined. One roughneck said, "Just tell them people that when they're driving around or sitting someplace warm to think of us working hard somewhere at the other end of that pipeline."

* * *

It was a cool autumn day when I finally left New York, but I put the top down anyway. The air was crystalline and intoxicating and the city hung in the rear-view like a lucid dream. In the industrial wetlands of New Jersey a peregrine falcon swooped low and flew right above the car for two or three seconds. He looked me square in the eye, which I took as a lucky sign. I remembered advice once given by a Sherpa: To find the trail, put down the map.

Rotary drilling rigs are huge, noisy, dirty, and immensely powerful machines. They move from place to place. Their working parts weigh in the

tons or tens of tons. They drill holes miles into the earth to find high pressure zones of combustible gas and oil. The work is dangerous and takes grit and muscle. A company woman from Pennsylvania said, "Just imagine a portable coal mine standing on its end in the open air and you get an idea of what roughnecking is all about." The oil industry didn't create roughnecks; it needed them.

Somehow from New York roughnecks had seemed exotic. But on the road my preconceptions were thrown back at me. On one offshore rig I watched a nineteen-year-old derrick man at work on the monkeyboard, a little platform about eight storeys above the drilling floor. The crew was tripping four miles of pipe out of a hole drilled in eighty feet of water. They pulled the pipe out in ninety-foot stands, twisting off each section and racking it before the next was pulled up. Each stand weighed about a thousand pounds and there were two-hundred stands screwed together to drill the hole. If left unchecked, the pressure of combustible gas downhole can be enough to blow the pipe through the top of a derrick like so much spaghetti, melting the entire rig for sauce. The derrick hand leaned way out off his perch to rope the top of each stand, then muscled it into the rack on top—all in time with the roughnecks working the floor. They kept the rhythm all morning. Finally, he put on the climbing belt and slid down the ladder like a fireman. We chatted as he scraped grease from his gloves and boots, and he asked where I was from. I told him and he said, "Man, I hear it's dangerous as hell up there."

The roughnecks on that rig were a tight crew and had just finished a seven-day shift offshore. On the crew boat back to the dock the married men sat alone and looked out the windows. The single guys, three roughnecks, combed their hair and shouted over the engine noise about a girl named Rhonda. The four of us drank some beer across the road from the dock and then I followed them on the long road to town. Every few miles a beer can popped out of a car window. The three of them stopped halfway for another six and as soon as we got to their apartment complex they headed out to ladies' night at a bar down the road. I passed out in a bean bag chair, exhausted from watching them trip pipe all day.

A few days later, on the way back from another rig, I picked up a six and dropped by their apartment. The non-stop seven-day-off party was going strong. Lots of people from the complex came and went—out-of-work roughnecks, some girls who worked in a hustle bar at the edge of town, the wife of a roughneck who was offshore that week—a constant flow. I suggested that one married woman might not want to be in some of the pictures since her husband might see the book. She said, "Hell no, I want to be in the book.

Don't worry about him. He don't read no books anyway."

After a while, in the gas stations and 7-11's and bars, when I asked about drilling rigs and roughneck hangouts, everyone assumed I was on the road looking for work and tried hard to help. My Fiat didn't look foreign anymore, just plain old. The election sticker that covered a rust spot had bleached white and the letters were gone. I lost the habit of shaving. My hardhat and coveralls got comfortable and grease-stained and smelled of diesel and drilling mud. Days passed on rigs and highways, evenings in bars, nights in motels. I didn't notice I was changing until a woman in a shopping mall in Midland locked all her car doors when I walked by with a bag of film.

The meetings with the executives generally came about by simply telephoning their offices from my motel rooms. In Dallas, even the asphalt is full of oil, and my tires squealed on slow curves. The men in the offices usually started by interviewing me to figure out what kind of book I was doing. That settled, I'd turn on the tape recorder and shoot pictures and swap stories. Some of the best stories started with *Cut that recorder off for a minute*. Almost all of the executives said that there are two types of roughnecks. One works a paycheck when he needs the money and then twists off. The other makes a career in the oil business.

There is some confusion in the field about who exactly is in the front office. I shot pool with one young Cajun roughneck on a rig out in the Gulf who kept asking questions. "Do you know who does the drilling for that Ewing Oil Company? I was just thinking, I wonder if I've ever worked for J.R.?" I told him that J.R. was just one of those fictional characters made up for T.V. and that there wasn't anybody drilling for Ewing Oil Company. He said, "It figures."

People everywhere talked nostalgically about the boom times of four or five years ago and said it was a shame I was down there during a bust. Drilling rigs were stacked out impotently along the highways. One hot day in Oklahoma I pulled into Wanda's Bar and Grill on the edge of Chickasha. Inside it was cool and dark and I drank a beer awhile before asking Wanda if there was any drilling going on. She said, "There's the man you ought to talk to," and a retired driller sat down and introduced himself. He said that three rigs had just moved in around "Surreal," which was just down the road between Cement and Apache. I followed his directions to a rusting gas refinery that looked like an old Twilight Zone set. It sat near a gas station, with weeds growing around the pumps, and an unfinished motel, both abandoned. It was Saturday evening and the road was empty. The whole

town seemed deserted. One car was parked in front of the laundromat and in the open trunk there was a pair of Red Wing steel-toed boots and an old suitcase. Inside a young driller was taking his coveralls out of the dryer and I asked him where I was. "This here is Surreal," he said. "Didn't you see the sign?" An eery feeling persisted until I came across that sign. "Surreal" was spelled "Cyril."

After ten months and many thousands of photographs and miles, there was still something missing. I followed directions from bars to rigs to trailer parks without quite knowing what it was. One day the crew on a rig in the middle of a soybean field said that a roughneck from morning tour had a twelve day old baby and lived less than an hour the other side of Malakoff. He lived on a quiet road and didn't have a phone so they drew me a map and gave me his brother's phone number in case I got lost.

I drove by Mark's trailer twice before matching it with the drawing on the map. The driveway was full of pickups and music was coming from somewhere. I knocked on the door awhile then walked around back. There in the cool shade a half dozen kids played on a swingset and waded in a plastic pool. A group of men in cutoffs and tee shirts stood around a smokey grill while their wives and parents made small talk around a picnic table. Mark walked over carrying his baby and I told him what I was up to. "Well you sure came to the right place. We're about all roughnecks here, my whole crew. Grab yourself a beer and sit down. Steaks be ready in a minute."

I met Mark's wife and parents and brother and his friends; everyone was smiling. The steaks came off the grill with the potatoes, and the salad came from the garden. They toasted a friend of theirs who was in the hospital and asked me to take a photo to send him. They toasted my book. The food was good and the kids ate with their fingers. I cranked the ice cream maker while one of the kids sat on top to hold it down. Mark added more rock salt and ice. I took some more photos and somebody said I had to say *one-two-three* so he wouldn't blink, and when I did he mooned the camera and everybody laughed. One of the guys picked up his toddler and said, "I guess you might call this a future roughneck."

Soon the ice cream was gone and the kids fell asleep in their moms' laps. There was still plenty of beer and the men swapped thick-tongued tales of big rigs and tough holes and tougher roughnecks. The wives finally got everyone moving; old friends said goodnight with hugs and backslaps and sweaty handshakes and laughter. I left the top down for the moon and realized the trail had come all the way around. The next day I flew back to New York to try to put it together.

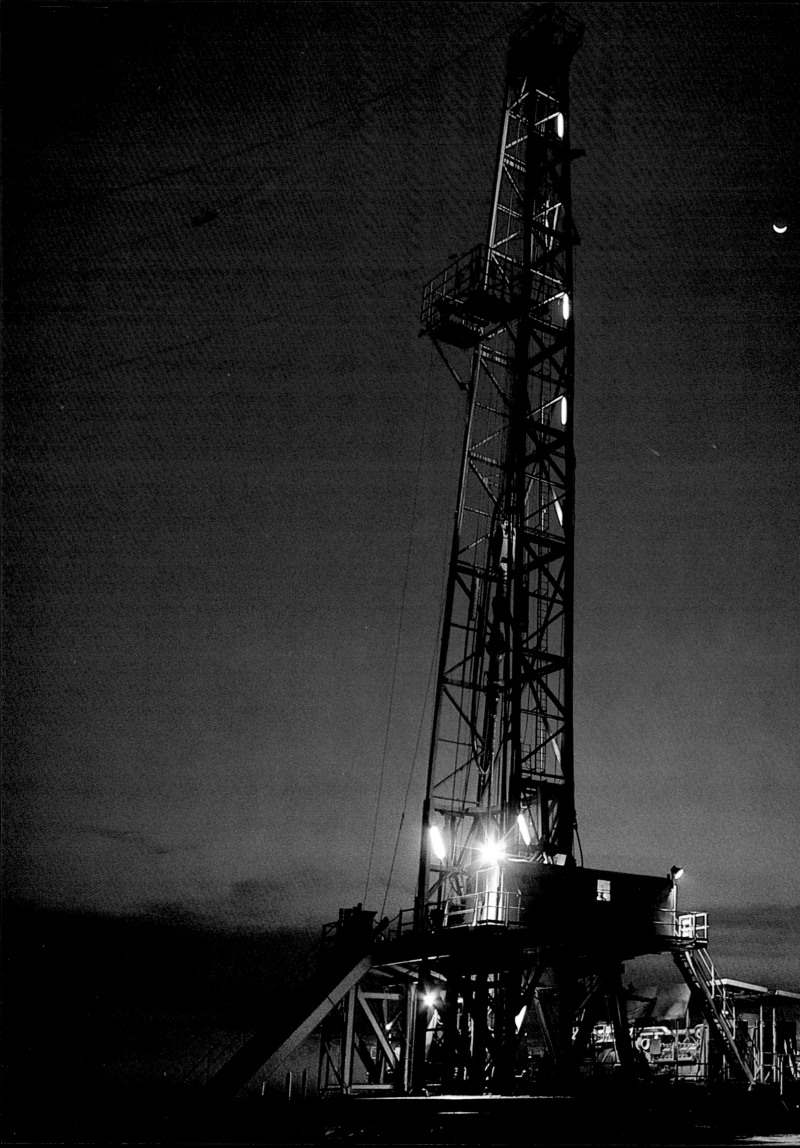

RIGGING UP

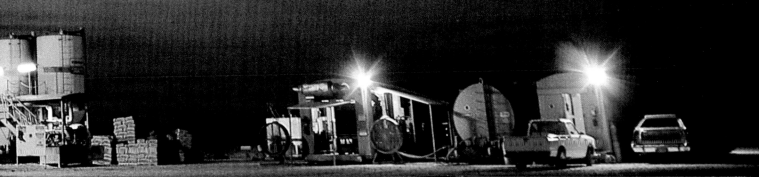

"The majority of the people out in this part of the country are employed in the oilfield but they are not all roughnecks. Roughnecks work on drilling rigs. They consider themselves the elite of the oilfield."

ECTOR COUNTY DEPUTY

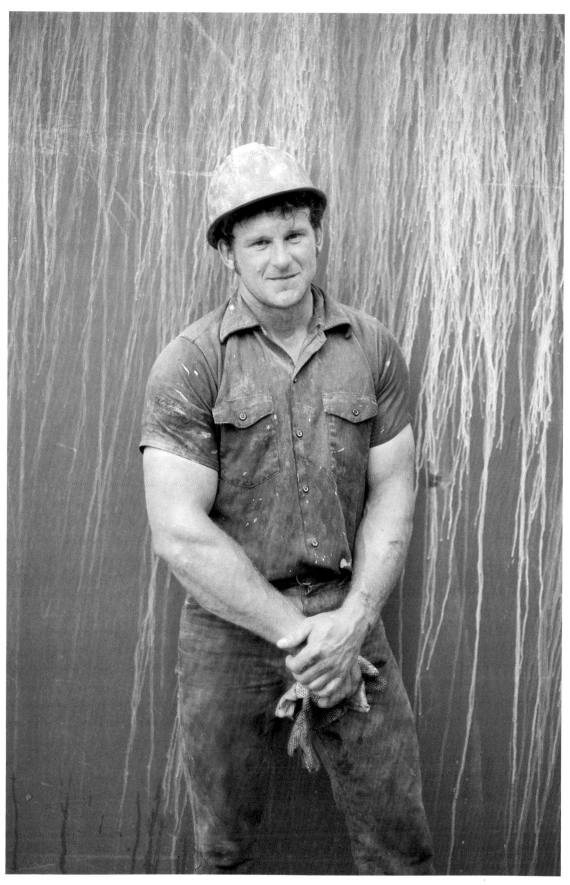

DONALD, ROUGHNECK

"If you're timid and shy, you'd better just stay out of the oilfield 'cause it's a rough, rowdy occupation. A roughneck look you square in the eye and tell you something, you better pay attention to him."

DRILLER

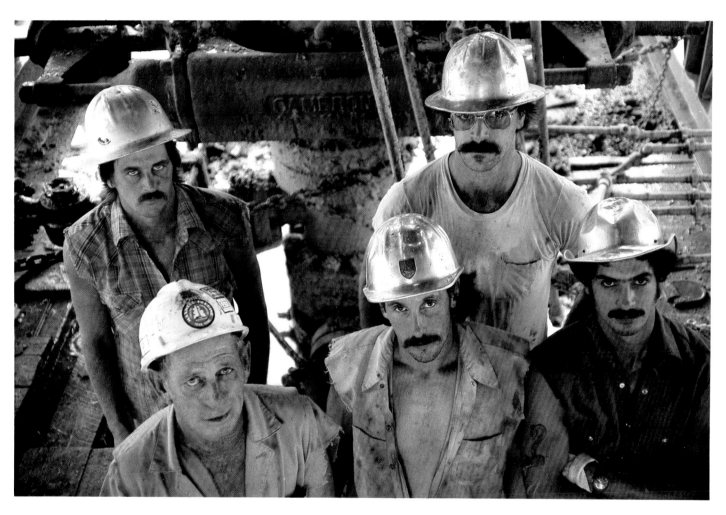

DRILLING CREW
CRESCENT HEIGHTS, TEXAS

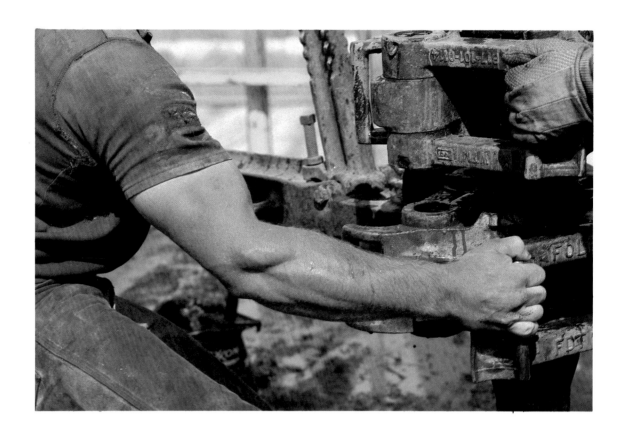

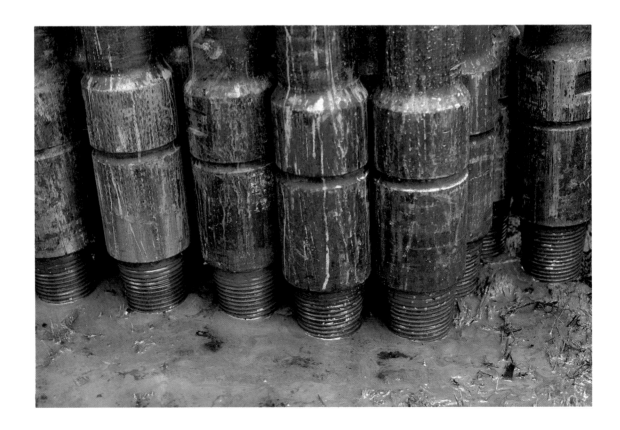

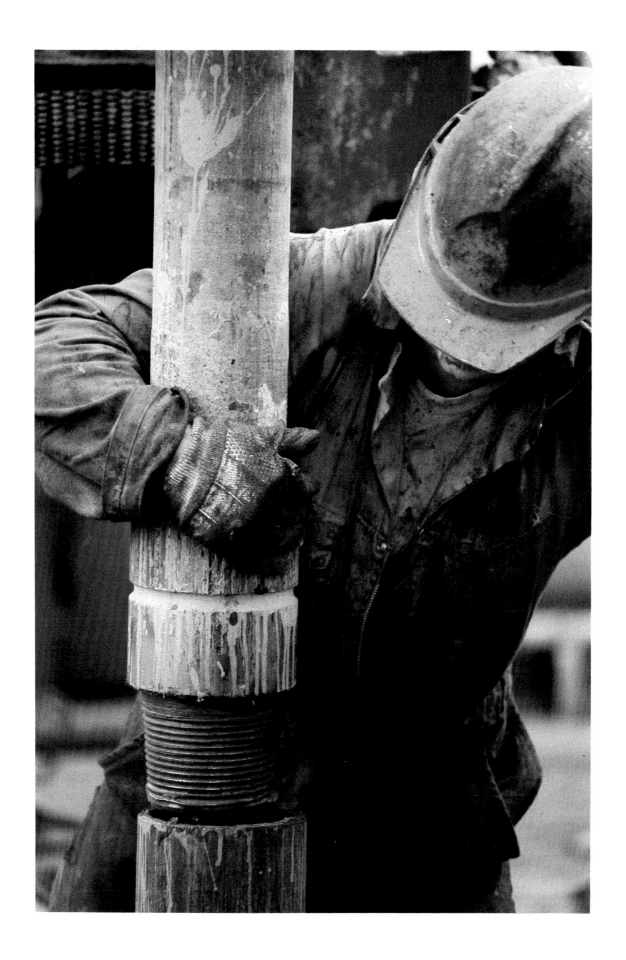

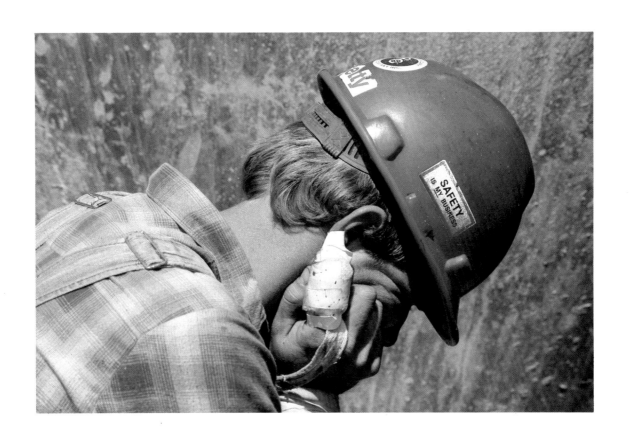

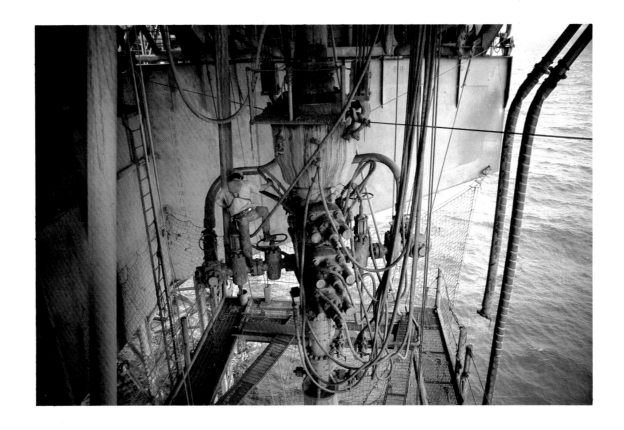

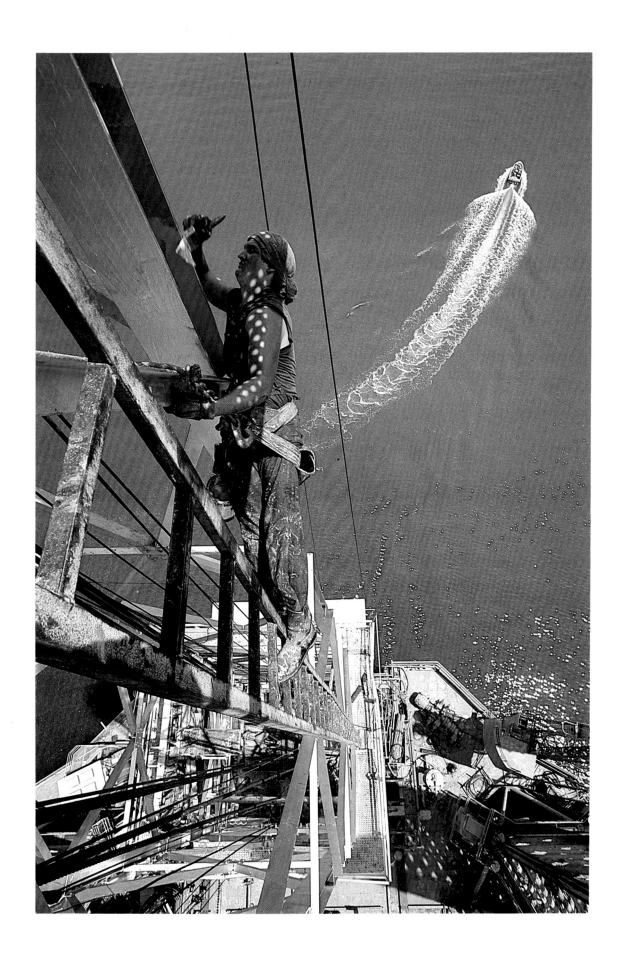

"When you start, you don't know nothin'. That cotton-pickin' iron is so heavy. And it's merciless too."

ROUGHNECK

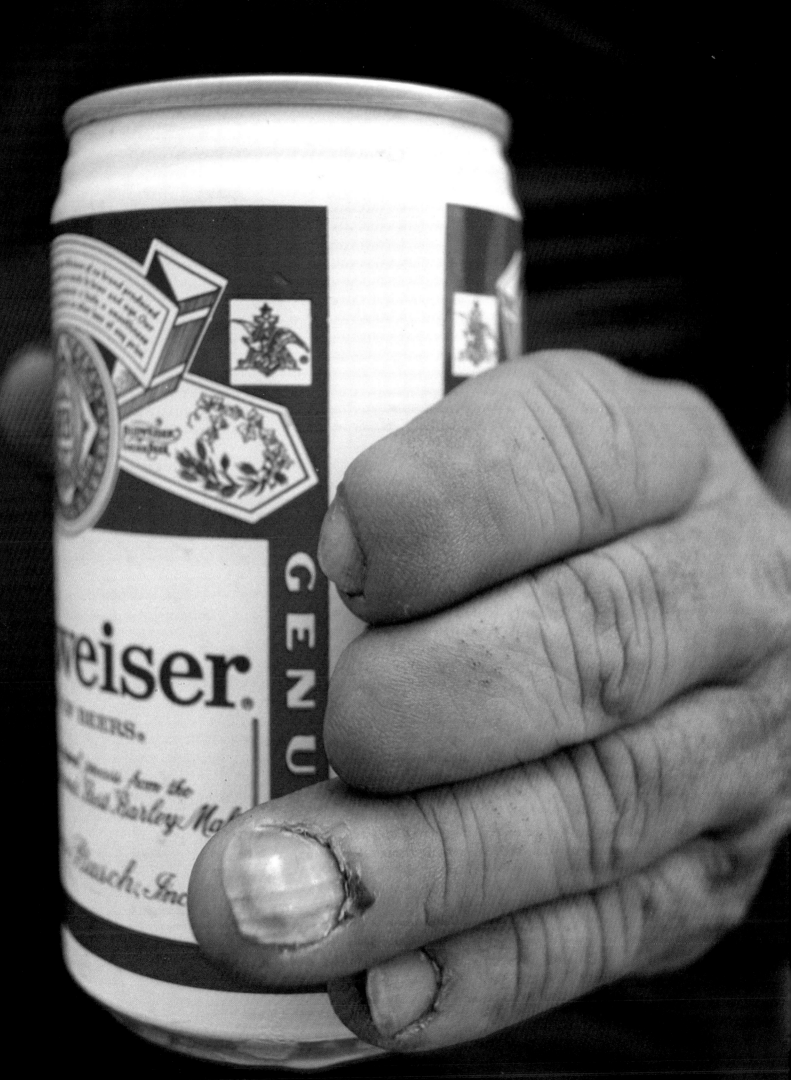

"I'll just tell you what the driller told me when he broke me out. He said, 'If you're willing to work I'll make a rough-neck out of you.' That's what I tell them when they want to break out and run a rig. If you're willing, you'll make one. If you ain't, you'll never make it."

TOOL PUSHER

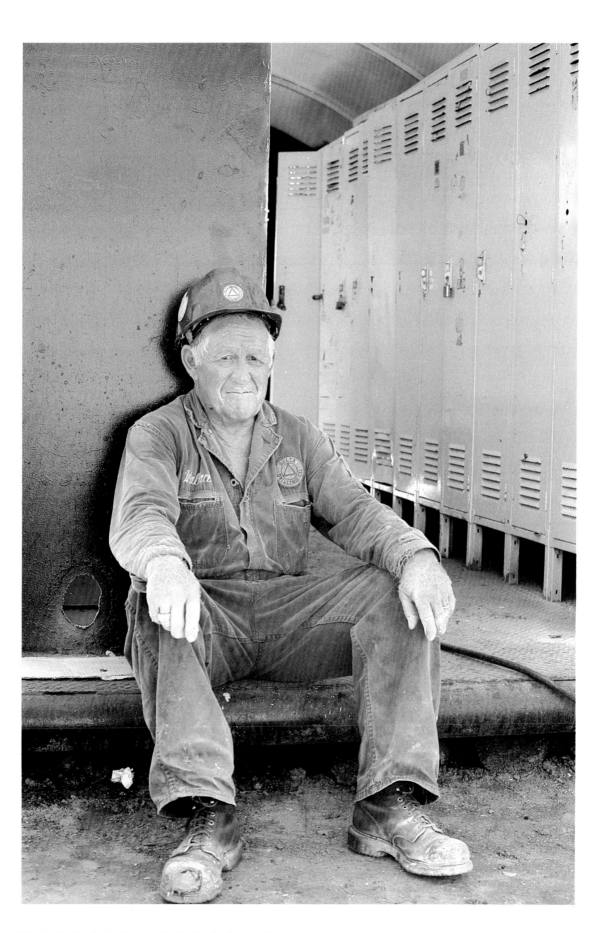

W A L L A C E , C R E S C E N T H E I G H T S , T E X A S

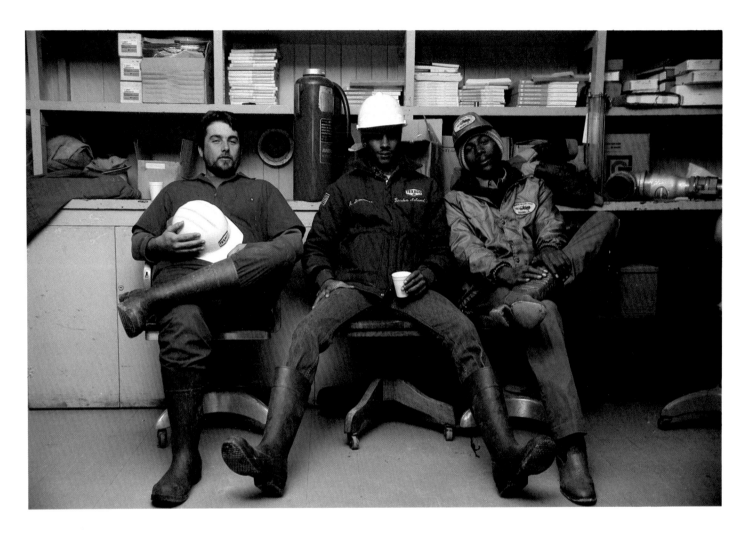

R O U S T A B O U T S , P A R A D I S , L O U I S I A N A

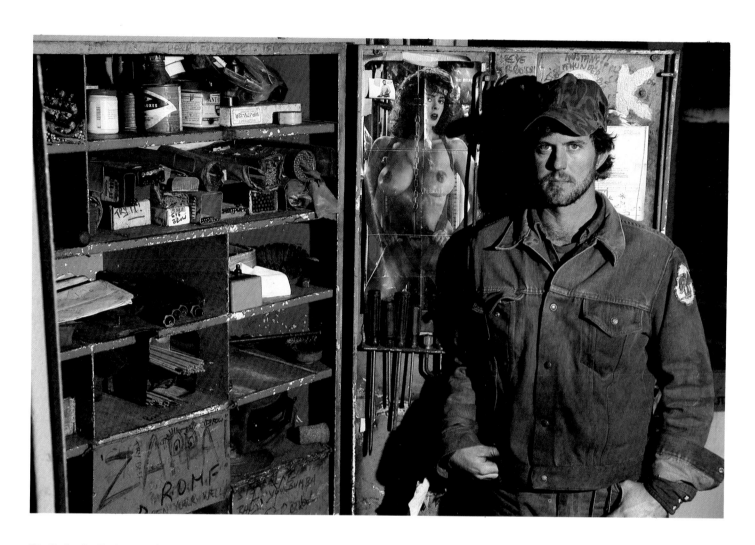

WELDER, OFFSHORE VENICE, LOUISIANA

DOG HOUSE, VALENTINE, LOUISIANA

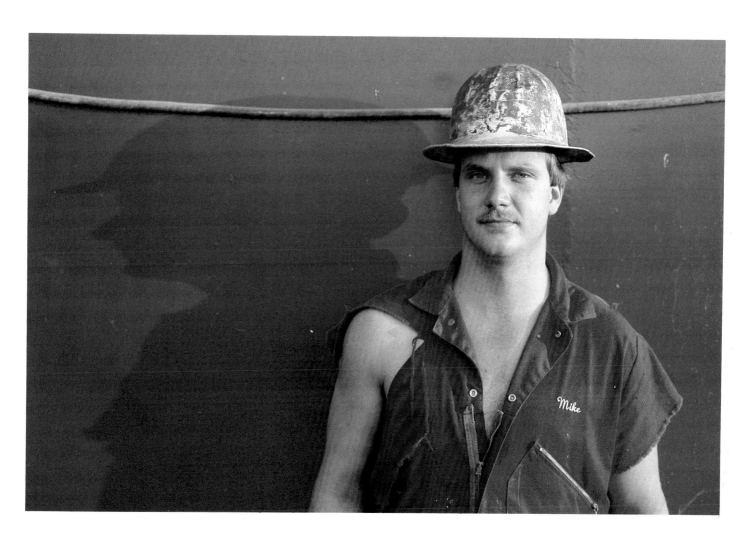

ROUGHNECK, LAKE MURRAY, OKLAHOMA

"If it wasn't for roughnecking, I wouldn't have this car. Well, that, and I'm single. And I don't drink."

ROBERT

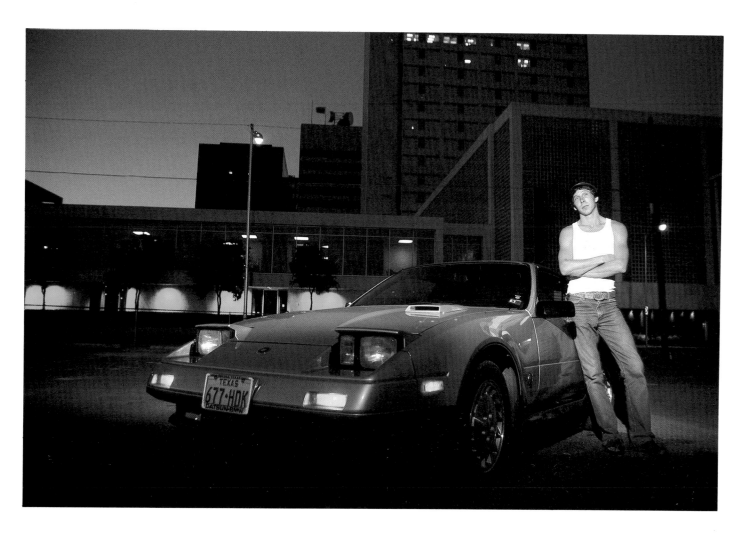

ROBERT, MIDLAND, TEXAS

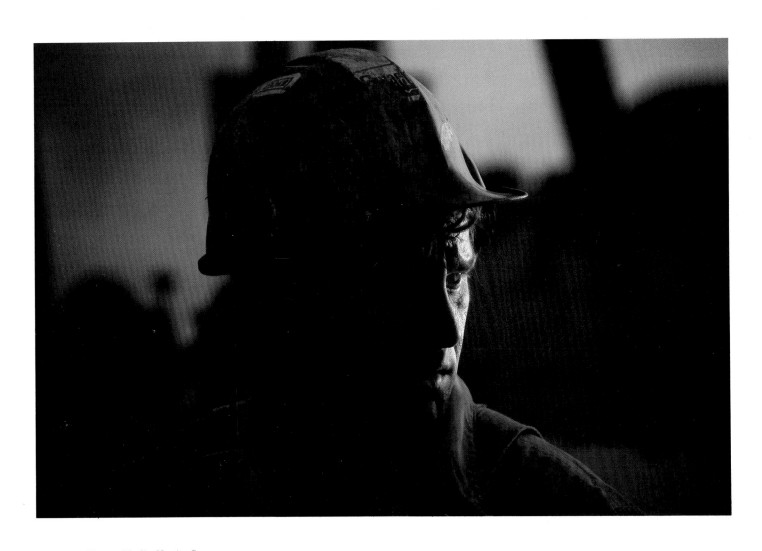

KATY, TEXAS

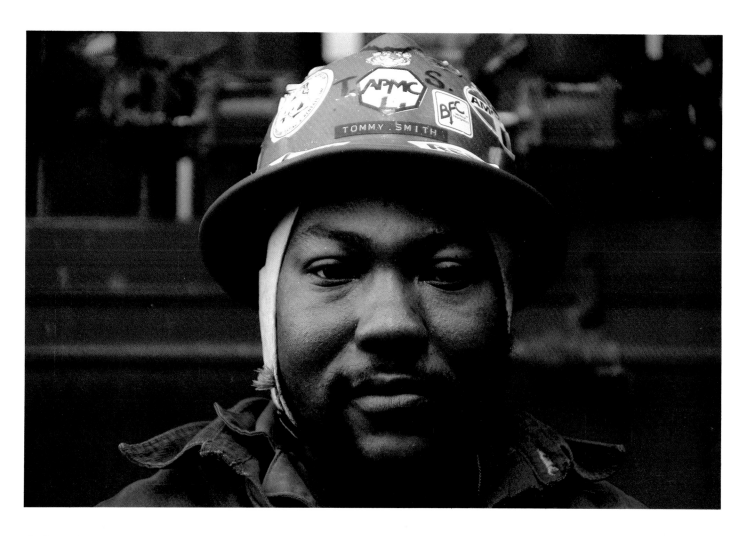

OFFSHORE INTERCOASTAL, LOUISIANA

"Roughneckin' is a life-style. If it was just a job it would be like any other job. But roughnecks tend to develop habits that don't go along with any other occupation. They move from one rig to the next and they don't give a damn. They just follow the bones. Nomads, I guess, is what you'd call 'em."

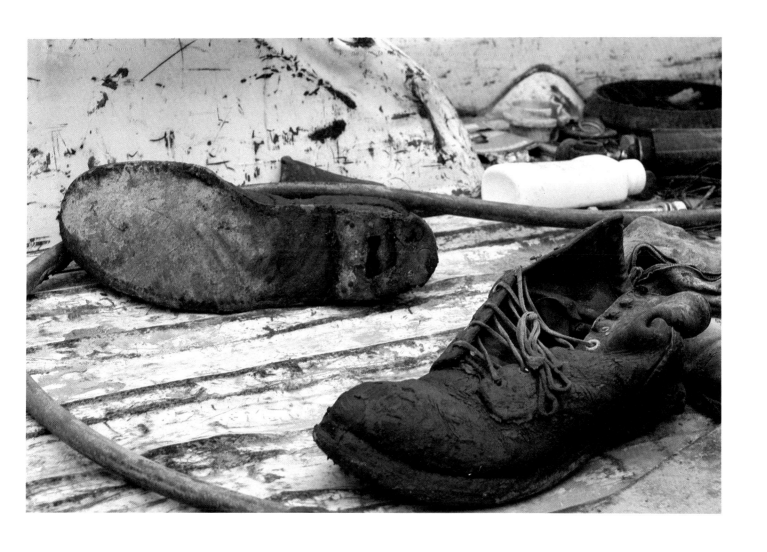

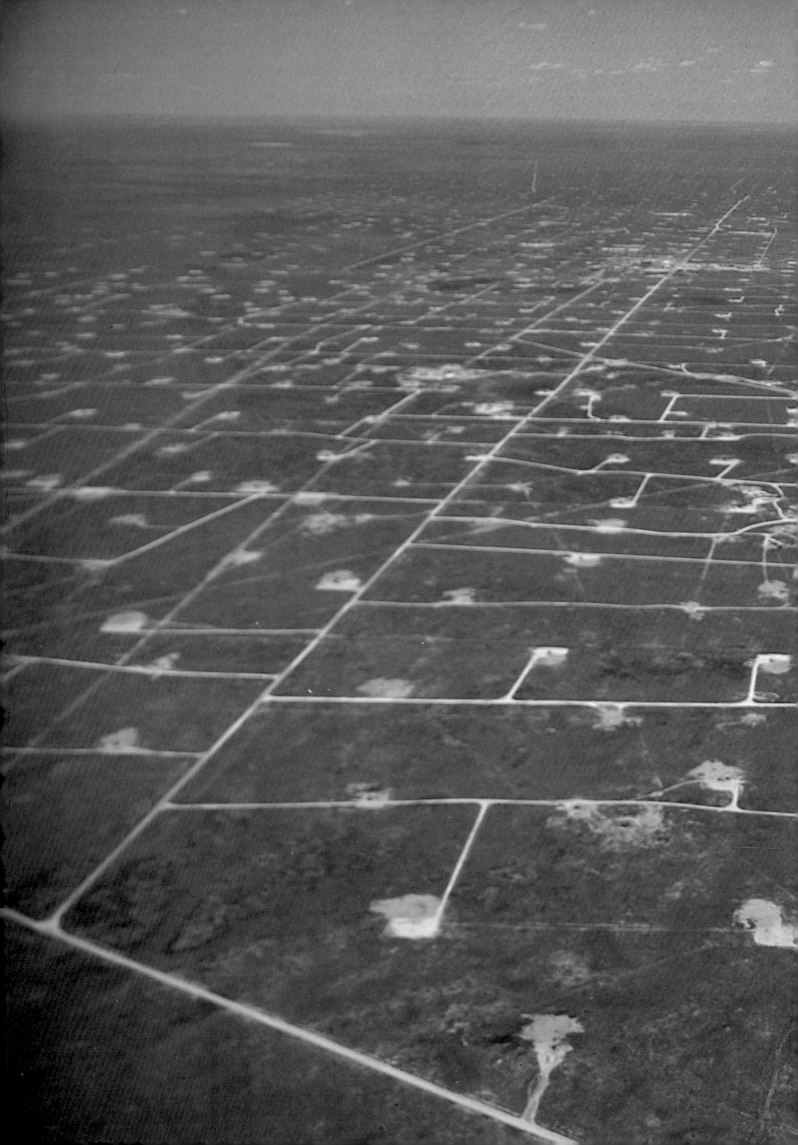

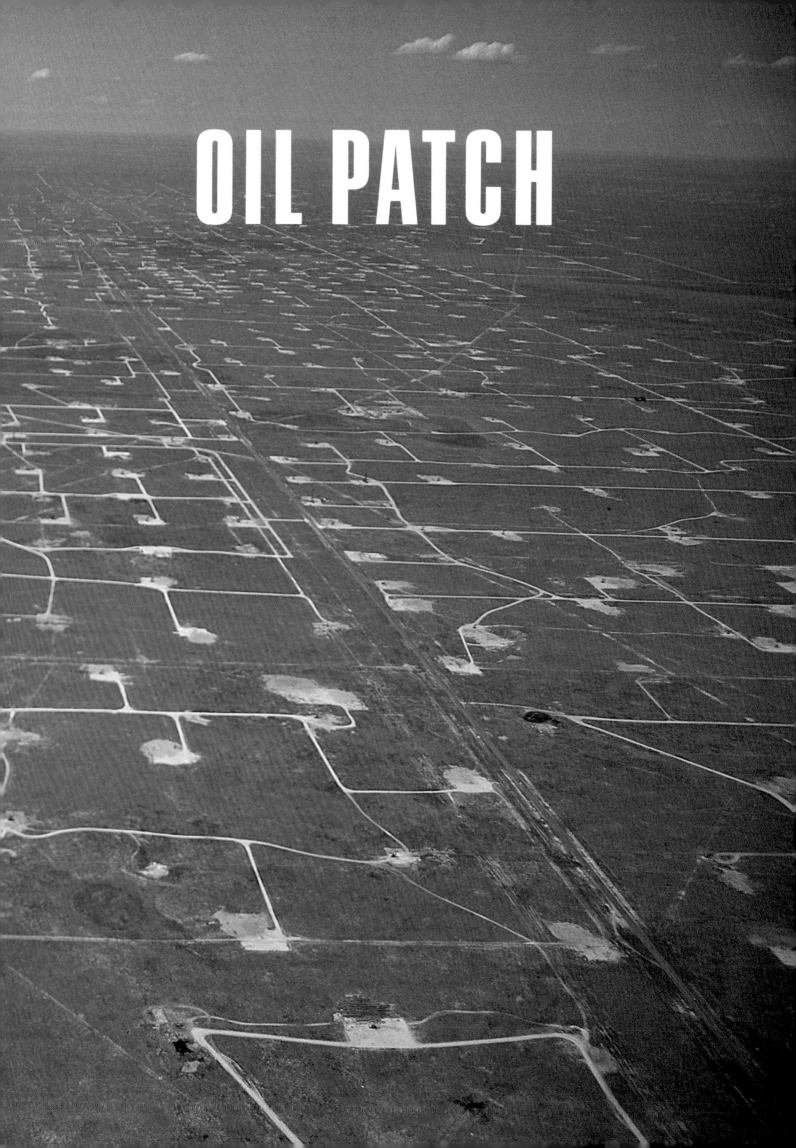

OIL PATCH

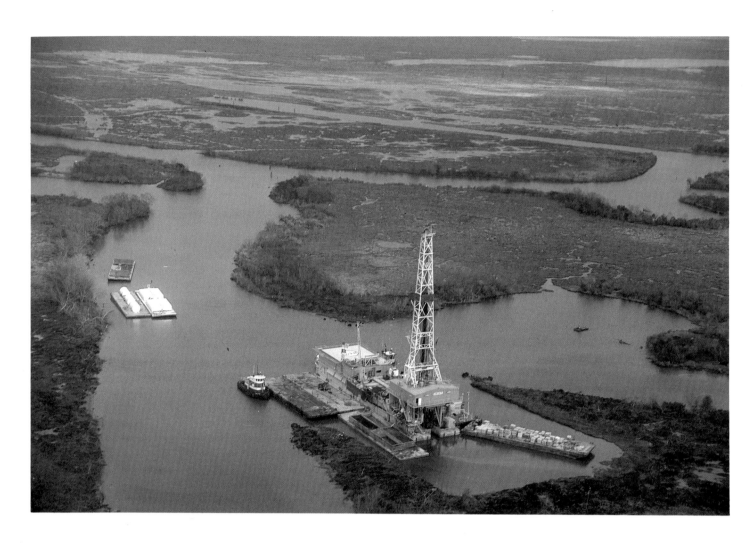

T E R R E B O N N E P A R I S H , L O U I S I A N A

O I L F I E L D , N O T R E E S , T E X A S

GULF COAST REFINERY

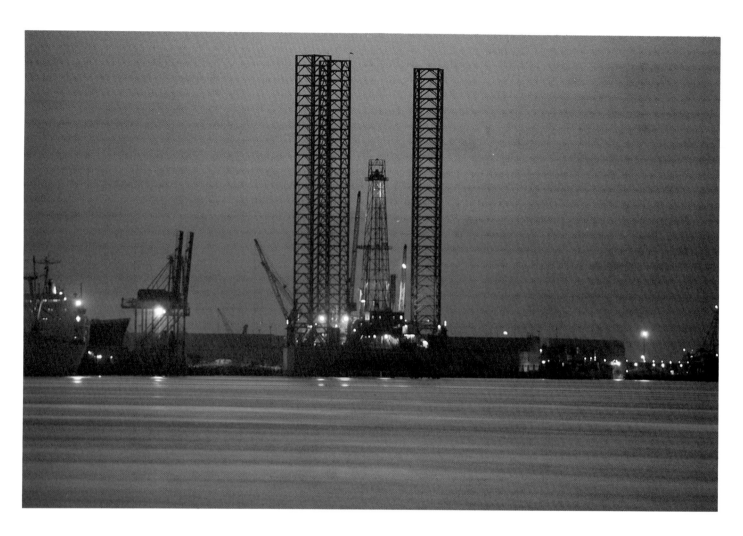

GALVESTON, TEXAS

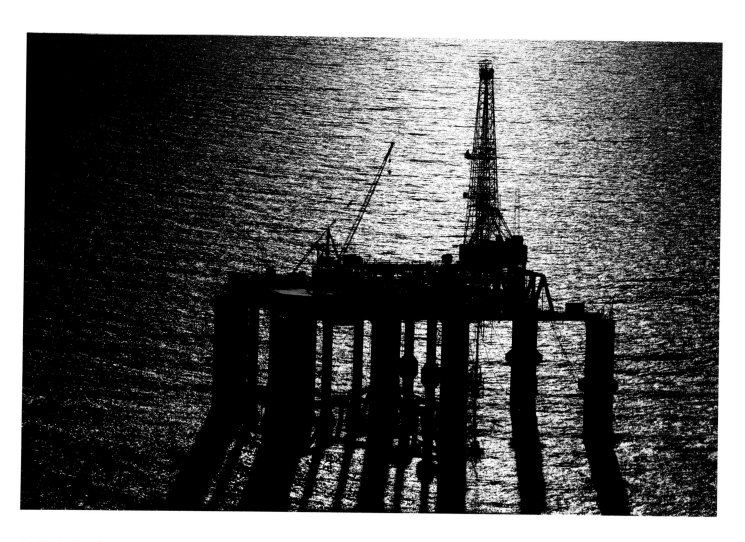

GULF OF MEXICO

"There's a lot of people that drift through here. Out of the steel mills and auto plants up in the Northeast there, 'cause they've been starved out. But they just ain't geared for this life-style. They make a payday and they go on hunting something else. There's just a certain breed of people that stays."

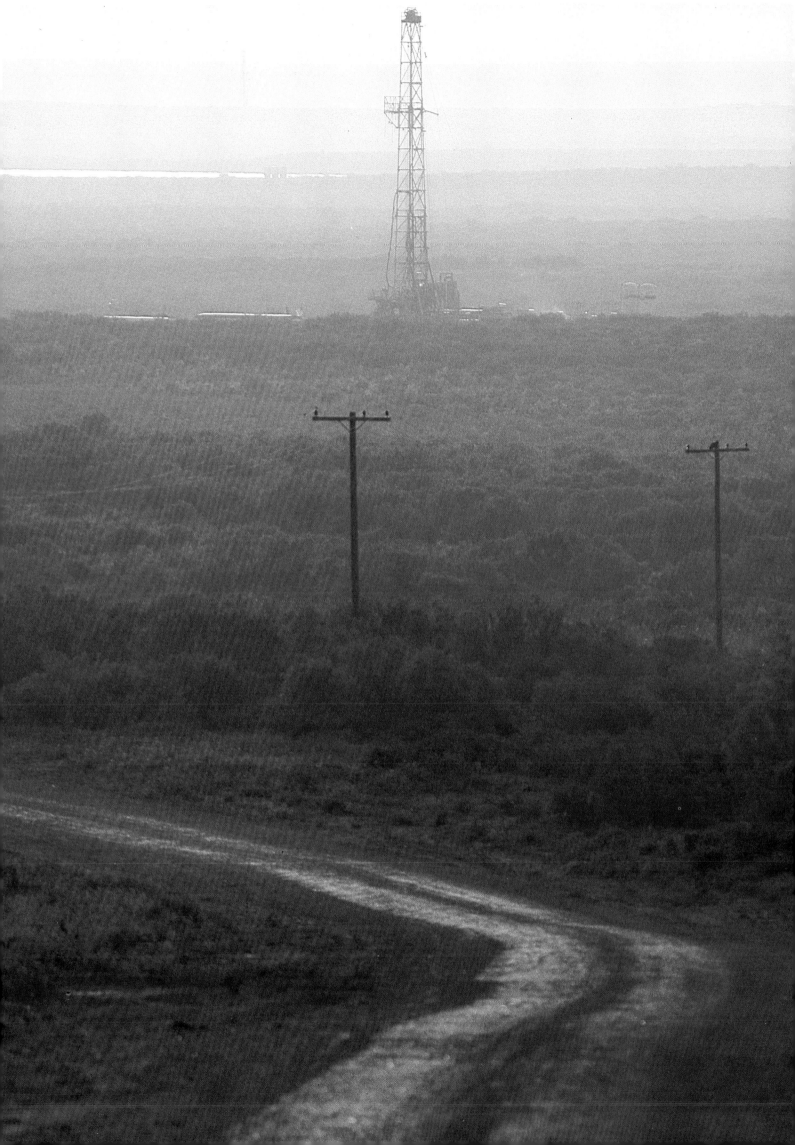

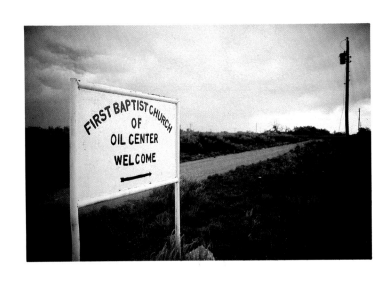

OIL CENTER, NEW MEXICO

"I don't have very far to go home. I live just down the road here, about an hour and forty-five minute drive. That's a real little-bitty old town. You ever watch Andy Griffith? You ever see that movie? Well, that's the kind of town I live in. Real friendly people. I enjoy livin' there. I bought myself a house there."

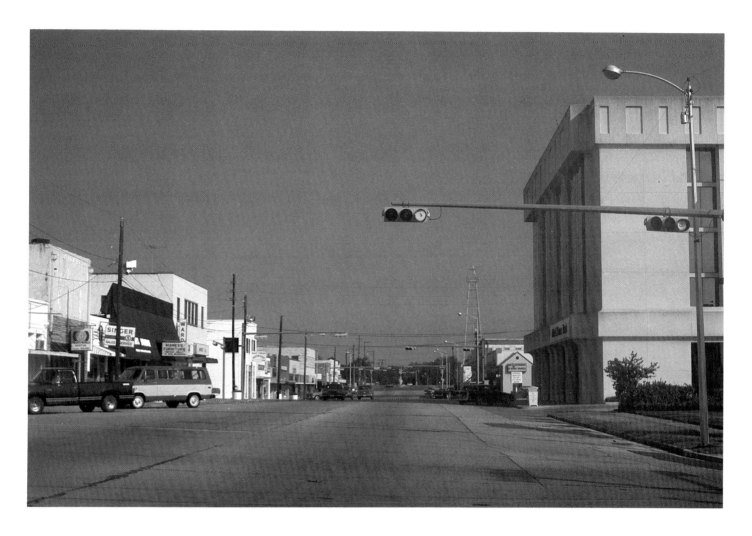

KILGORE, TEXAS

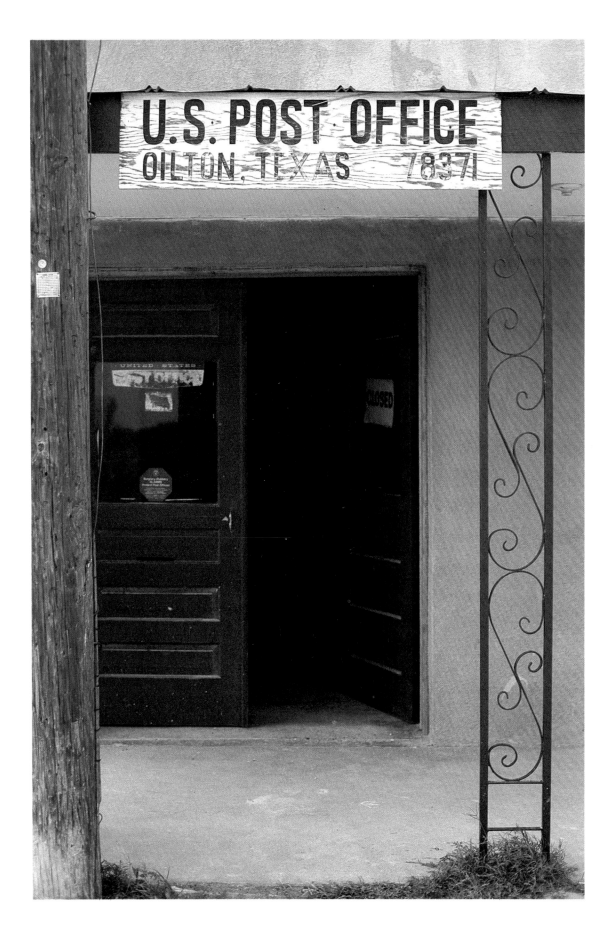

OILTON, TEXAS

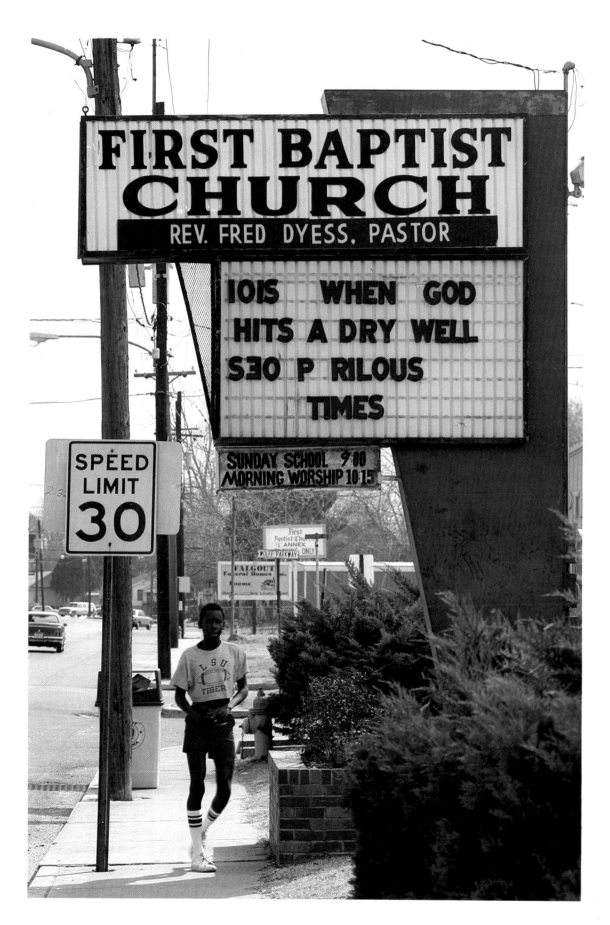

FIRST BAPTIST
CHURCH
REV. FRED DYESS, PASTOR

IOIS WHEN GOD
HITS A DRY WELL
S3O P RILOUS
TIMES

SUNDAY SCHOOL 9 00
MORNING WORSHIP 10 15

SPEED
LIMIT
30

HOUMA, LOUISIANA

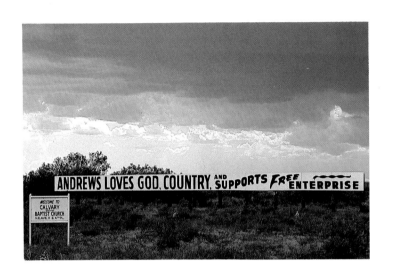

W E S T T E X A S

"Some people don't like the smell. But I tell you it's worth the smell, the money that's in it. We really do good, and we have whatever we want. We raised our family in the oil-patch."

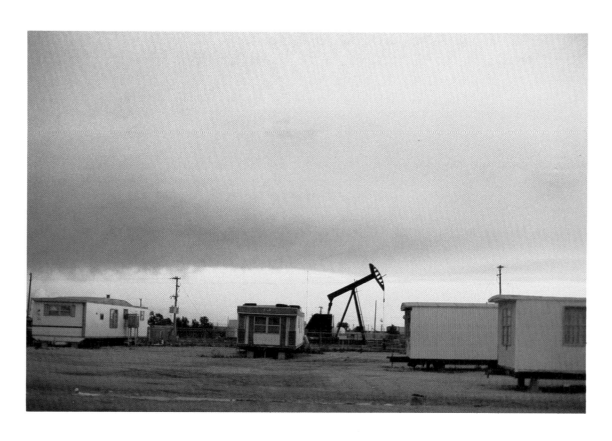

HOBBS, NEW MEXICO

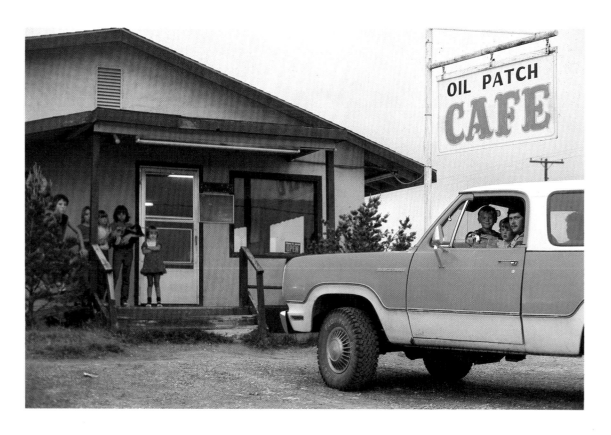

EUNICE, NEW MEXICO

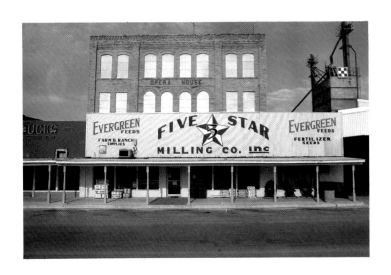

"I've seen quite a few booms. I've seen a time where right up here I've stood on the derrick floor and counted 75 to 100 rigs runnin'."

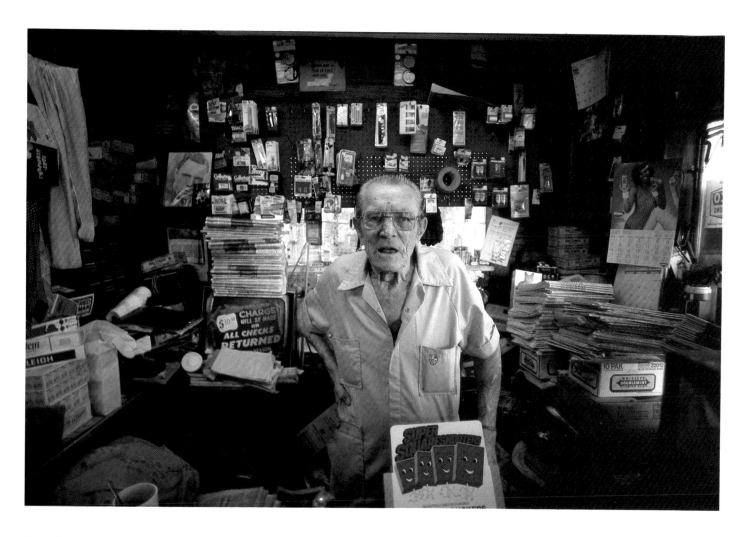

OIL CENTER STORE, EAST TEXAS

"West Texas is the best place I ever found to work in. The climate is good. You ain't putting up with a lot of rain. It's not real cold. It's usually hot and dry and that don't hurt you. It just gives you a better suntan."

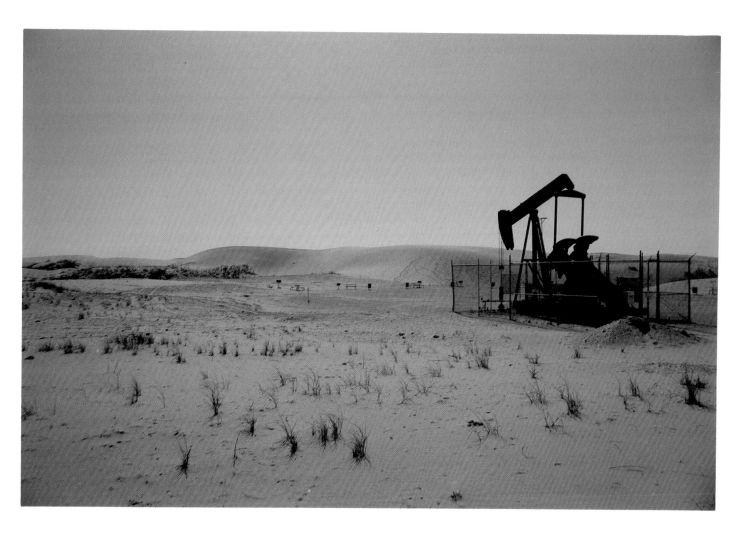

MONAHAN SAND DUNES , WEST TEXAS

"When the rig gets stacked, if you ain't ready for it—if you ain't got a little bit of something saved—then you have to leave town and go somewhere else and work at whatever you can until the oilfield picks back up. Right now there's a lot of people out of work."

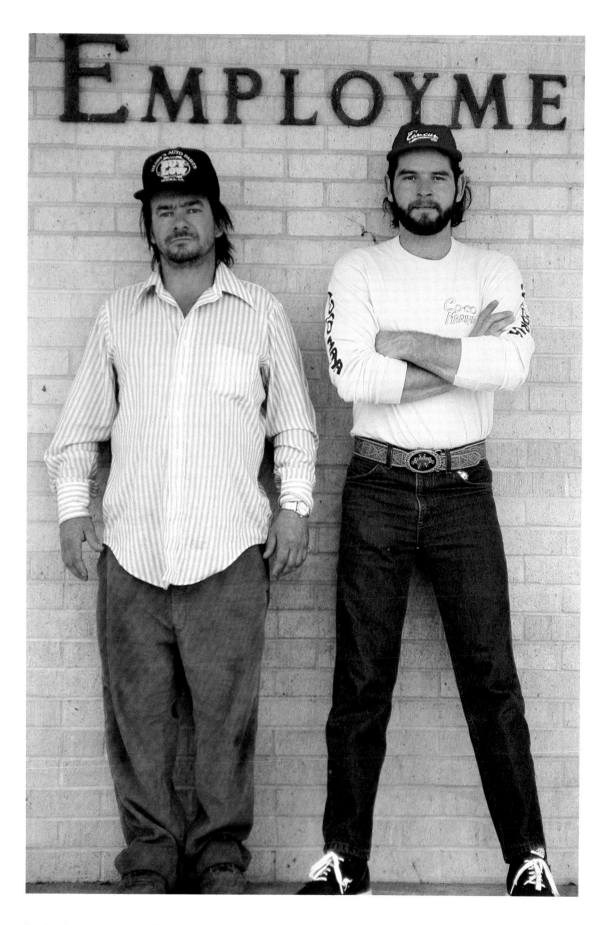

HOUMA, LOUISIANA

"Oilfield is a big deal. It's hard to think about what all is involved in it. If the oilfield shuts down, you know we'd be out of a job. But there's so many people involved. Pipe fitters, casing crews, inspectors, cementers, and loggers, and roustabouts. Then you've got welders, plumbers, electricians, and location builders. Small independent business people. Just look at the truck drivers that would be out of work. You got to haul the pipe, haul the mud, haul the rigs. It's a big network for the oilfield. Without us there'd be no gas, no cars. Then look at all the things that are made from oil. Plastics and everything. God only knows what all is made from oil. Tennis shoes! It's not just the gas you put in your automobile."

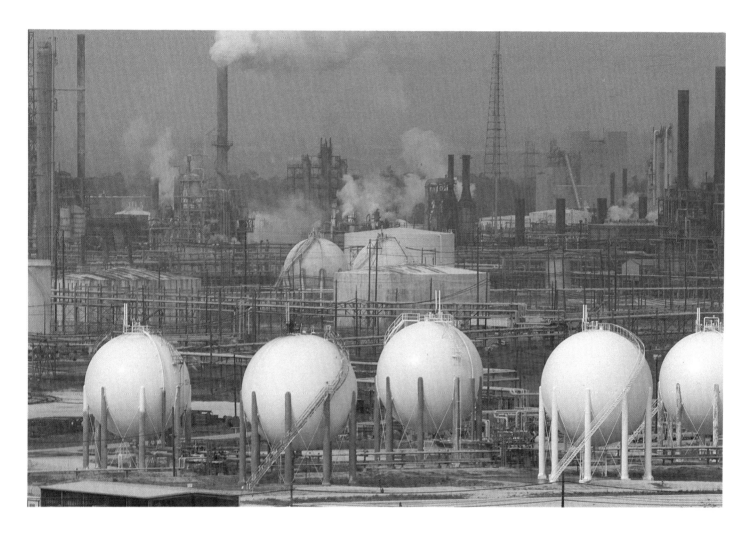

G U L F C O A S T R E F I N E R Y

FRONT OFFICE

"We got men out here with a fourth grade education earning fifty thousand dollars a year."

TEXAS RICHARDS

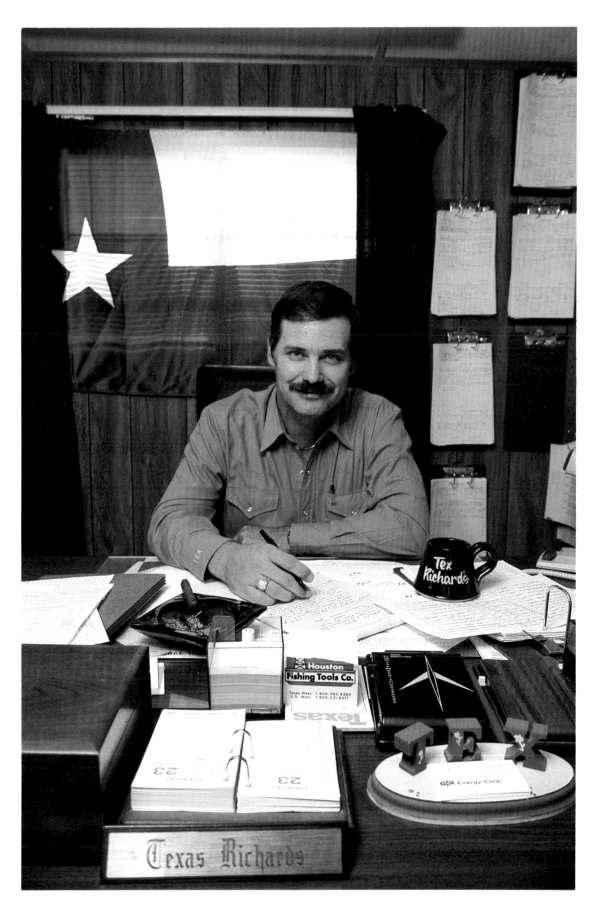

TEXAS RICHARDS, LAREDO, TEXAS

"Of course, I started in the oilfield before they were offshore. They were all on land and it was eight hours a day, seven days a week. No time off. Where in hell the rig moved, you moved. Boarding house to boarding house. When the rig worked, you worked. And when the rig was down, you were off.

Now they have a little more equipment, air hoists, spinning wrenches, iron roughnecks, and all that stuff. But roughnecking is basically the same."

JOHN CARPENTER

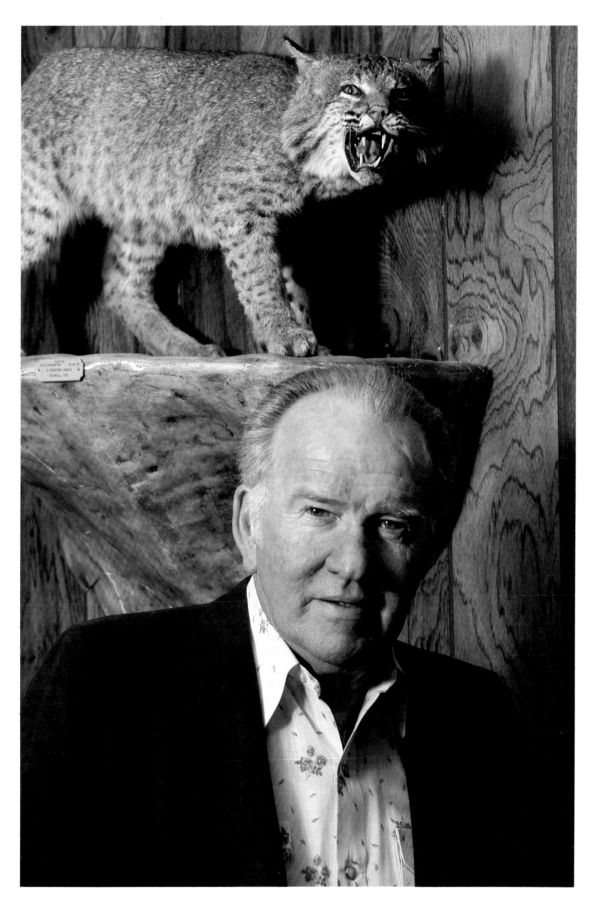

JOHN CARPENTER
NEW ORLEANS, LOUISIANA

"It's not only the roughnecks, it's all the people in the industry that are significantly a breed apart. People who thought you could not solve a problem have never lasted in this industry. Didn't make a difference what had to happen. You just figured out a way to get it done. Combine that with the ability to withstand adversity, the ability to take great risks and be responsible for whatever the result, and you've got the difference. You've got your tremendous ups and downs. I mean you can be absolutely rich one day, and broke the next. Excitement at all levels, from the roughnecks to the company president, that's part of being in it. If you take the risk out, then it becomes a different industry.

During the boom, a lot changed. There were so many legal complexities to the crash that more money has been spent on lawyers than on drilling in the last couple years.

But the industry is one that survives. And now, the industry, especially the gas industry, offers more opportunity than I've seen in a decade."

ROBERT HEFNER III

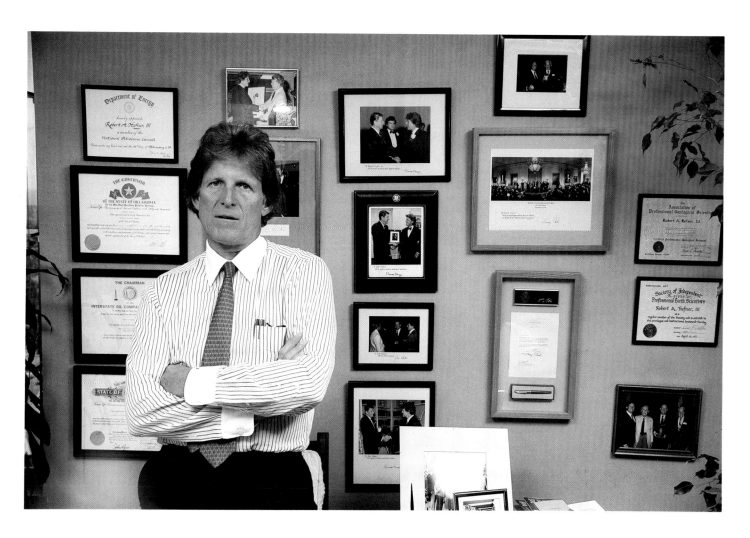

ROBERT HEFNER III
OKLAHOMA CITY, OKLAHOMA

"My father is a farmer. I got a high school education. I started off roughnecking and I started working for Penrod Drilling Company in 1947. I went from a roughneck to a driller, a driller to a tool pusher, a tool pusher to a superintendant, a superintendant to a manager. I've headed Penrod here in Dallas for 21 years. I put a lot into it. We got a bunch of rigs in the North Sea, a bunch down in Brazil, one in Greece, a couple in Dubai, and one in Indonesia. We've got something like 135 rigs. All our rigs together are worth about a billion three hundred million. The oilfield has been good to me. Anytime you can start off as a roughneck and end up running an outfit like Penrod Drilling, then you got a lot to be thankful for."

J. C. CRAFT

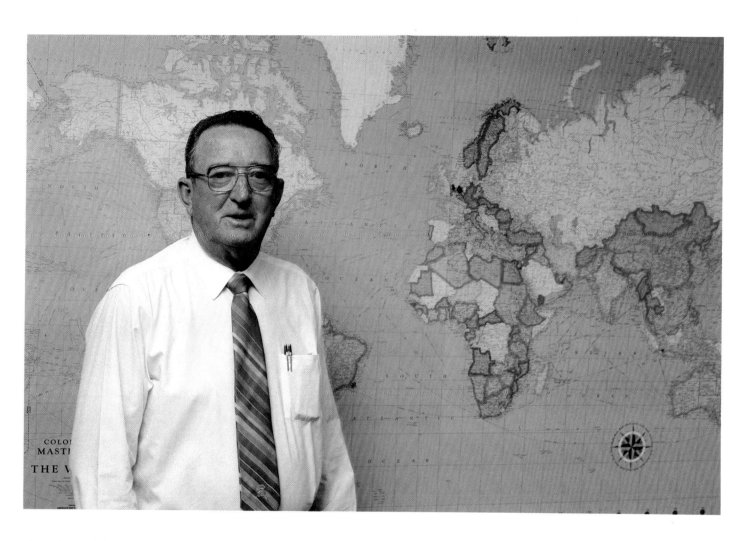

J . C . C R A F T , D A L L A S , T E X A S

"I roughnecked a little. It's pretty hard work. It'll make you appreciate the value of a dollar. If you put in your 8 hours you'll sleep pretty well that night. At least I did when I was working. I just roughnecked for one summer, about three months. I was fourteen years old. My father never suggested it at all. I just wanted to. I was precocious. Wanted to get the experience. I was young and dumb and thought I was strong, but found out I wasn't all that strong."

BUNKER HUNT

"My daddy would carry me around with him when he went out into the oilfield. I can remember that normally for him weekends were a time to go to the oilfields with the family. He always had some well drilling somewhere. I did roughneck as a kid. I guess I was seventeen. It was hot, hard work. I never was much of a fighter in those days. I found out that there was a bunch of guys out there that could whip me."

HERBERT HUNT

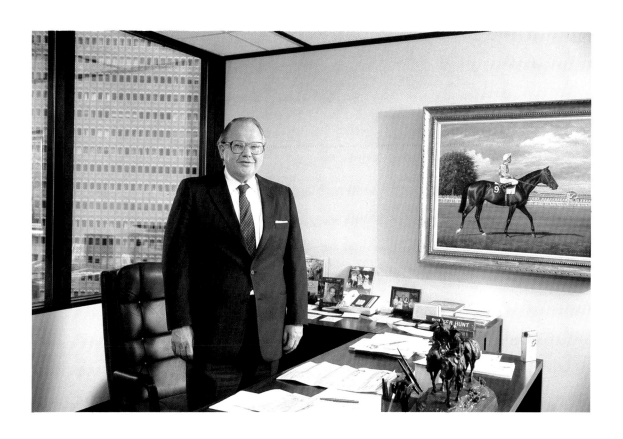

B U N K E R H U N T , D A L L A S , T E X A S

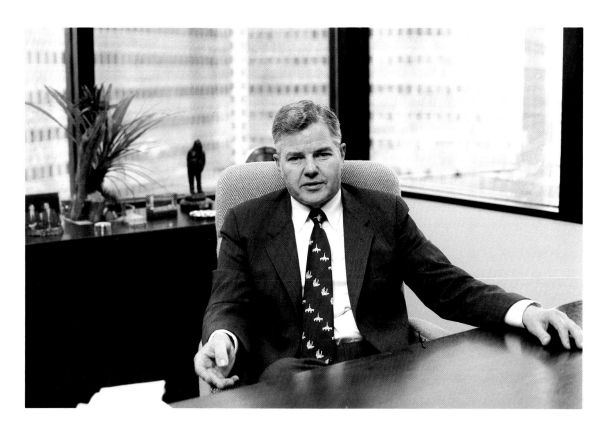

H E R B E R T H U N T , D A L L A S , T E X A S

"I worked one summer as a roughneck, but I spent about three or four years as a well-site geologist. Out there they don't like somebody with an education, you know, the smart son-of-a-bitch. They'd always tell me this joke about geologists. I've had roughnecks tell me this joke a hundred times: This drilling contractor was drilling his own wells and he had a geologist. The drilling contractor came out to the rig one day in a new pink Cadillac with a whore in the front seat, and a horse trailer tied on. And he comes in and walks up on the floor to see the driller. And he says, 'How are we doing?' And the driller says, 'Well, we're right on. We're right where we're supposed to have the pay-zone. Where's the geologist?' 'Aw,' the contractor says, 'I got rid of the geologist.' And the driller says, 'You got rid of the geologist!' And the contractor says, 'Hell yes, I did! I got me a whore and a race horse now. One of 'em's a lot more fun and the other's more reliable!' And boy, they loved telling me that story. And that's the way they felt about it too."

T. BOONE PICKENS

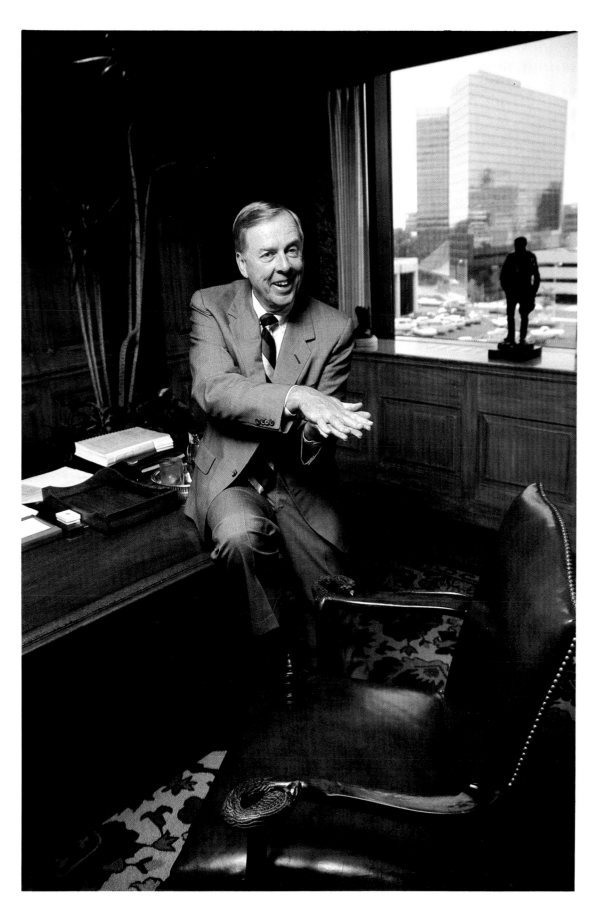

T. BOONE PICKENS, AMARILLO, TEXAS

"Rather than feeling dejected at mistakes he makes along the way, I think an oilman has got to look forward, hopefully, all the time."

W. A. "MONTY" MONCRIEF

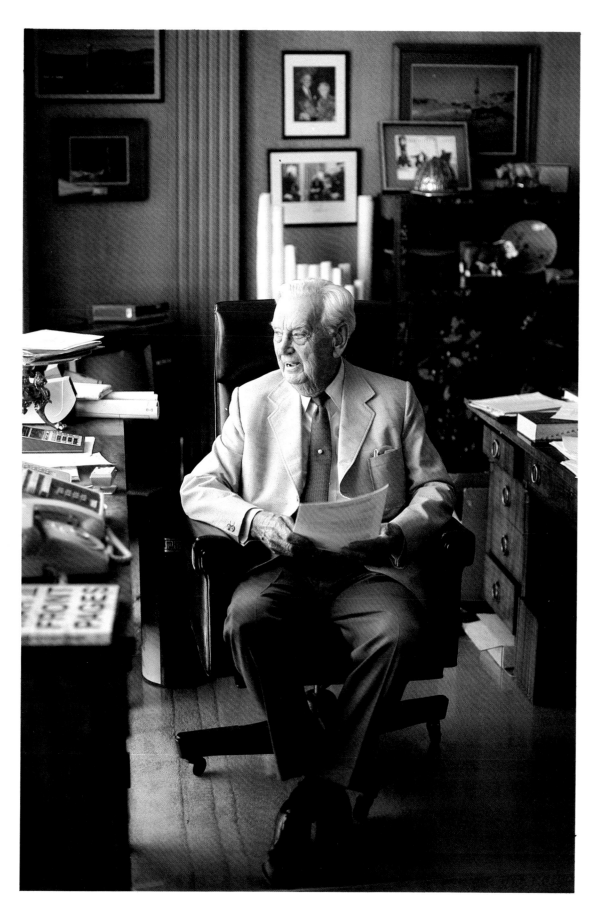

W. A. ''M O N T Y'' M O N C R I E F
F O R T W O R T H , T E X A S

"Roughnecks are the backbone of the oil industry."

RED ADAIR

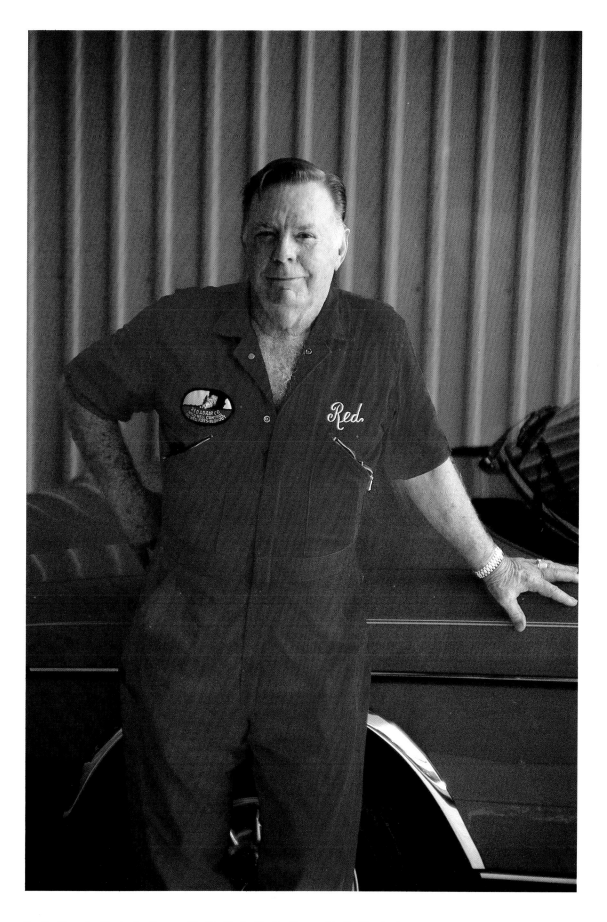

R E D A D A I R , H O U S T O N , T E X A S

"I'll tell you one thing I remember on this well that blew out. That the man that was paid the least was up there takin' the most risk on the well head when we was in trouble. At that time I gave them a bonus, from me to the roughnecks. Danger bonus. Because, really, they're like the infantry in the army. They're the guys who get it done, and they're neat people. They have a work ethic. I like 'em. They're proud of bein' strong. Roughnecks like to fight because they're strong. That's kind of a tradition. That's part of bein' a roughneck. You have to fight, go to a bar and fight. John Wayne told us to do that. But the roughnecks had that tradition long before he came along."

CLAYTON WILLIAMS

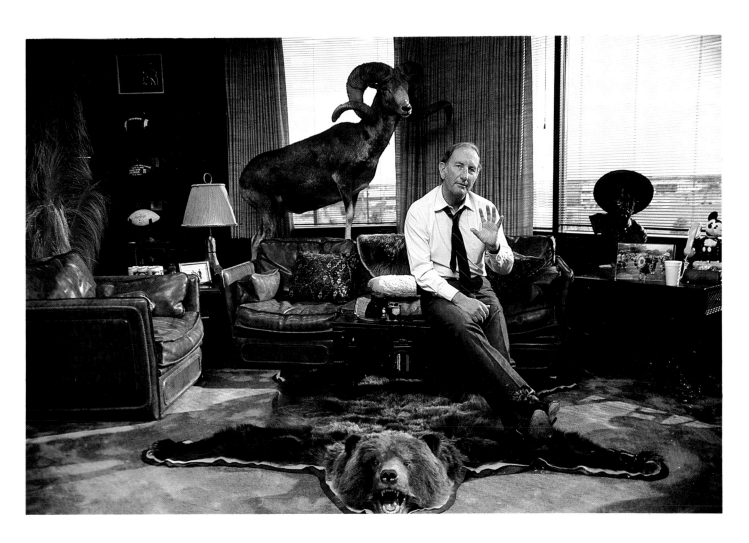

CLAYTON WILLIAMS, MIDLAND, TEXAS

TRIPPING PIPE

"Somedays it's especially cold or especially wet. Or you get cut, or banged up. It all takes its toll on you and you wish you weren't here. And then you get home and you get away from here for a week, and you say, 'Damn, I wish I was back at the rig.'"

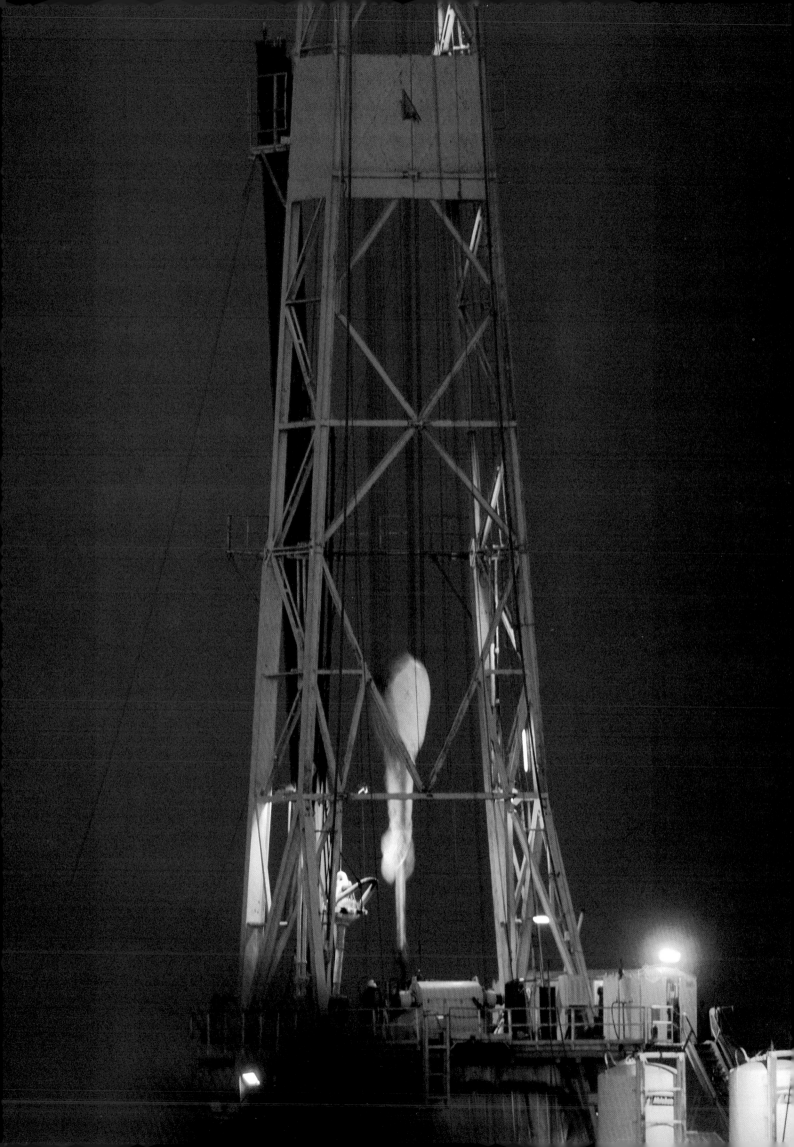

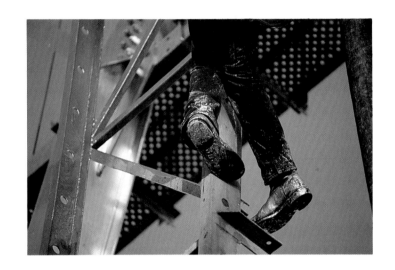

"You're working right there in all that iron, you know, things can happen if you don't keep your fingers in the right place."

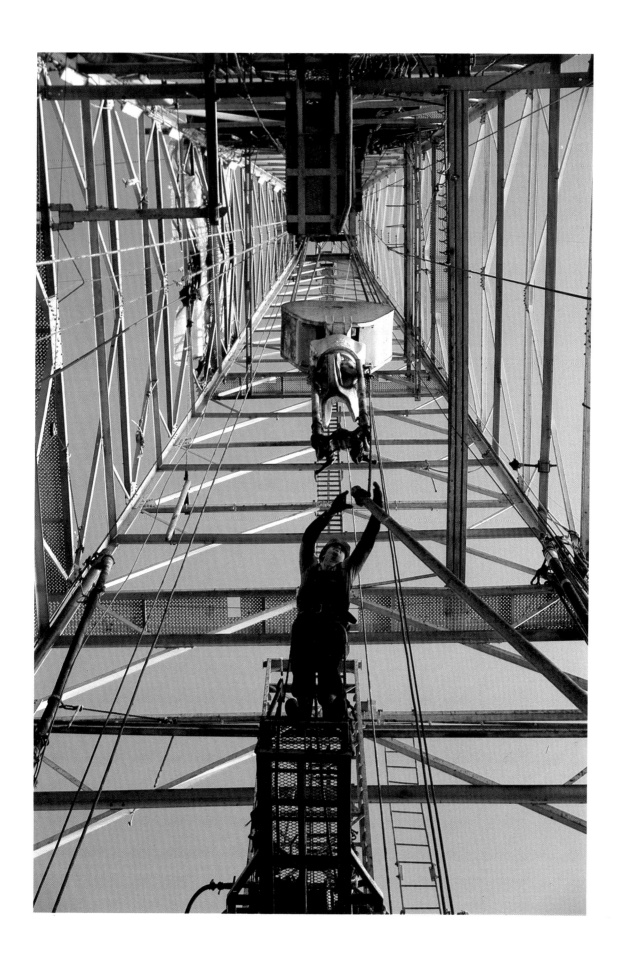

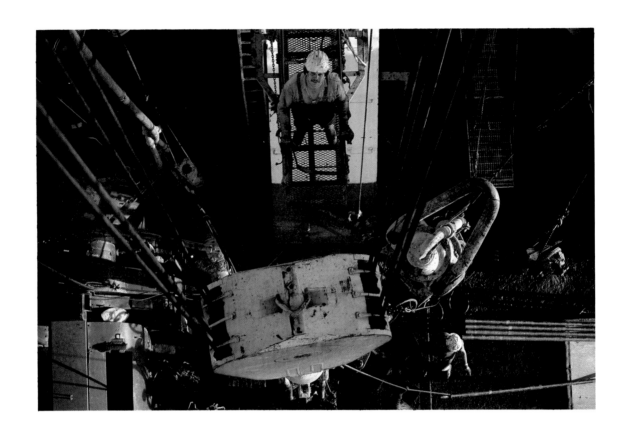

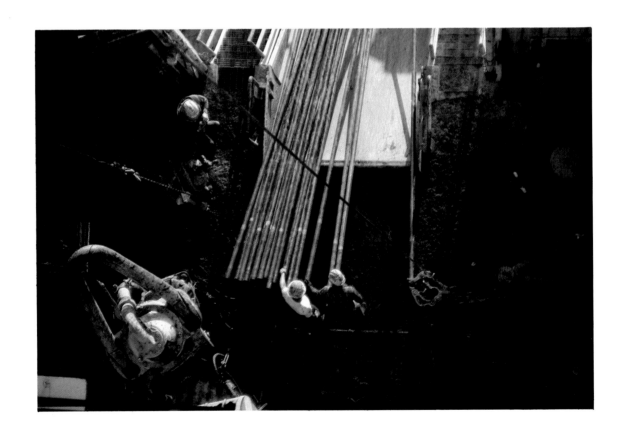

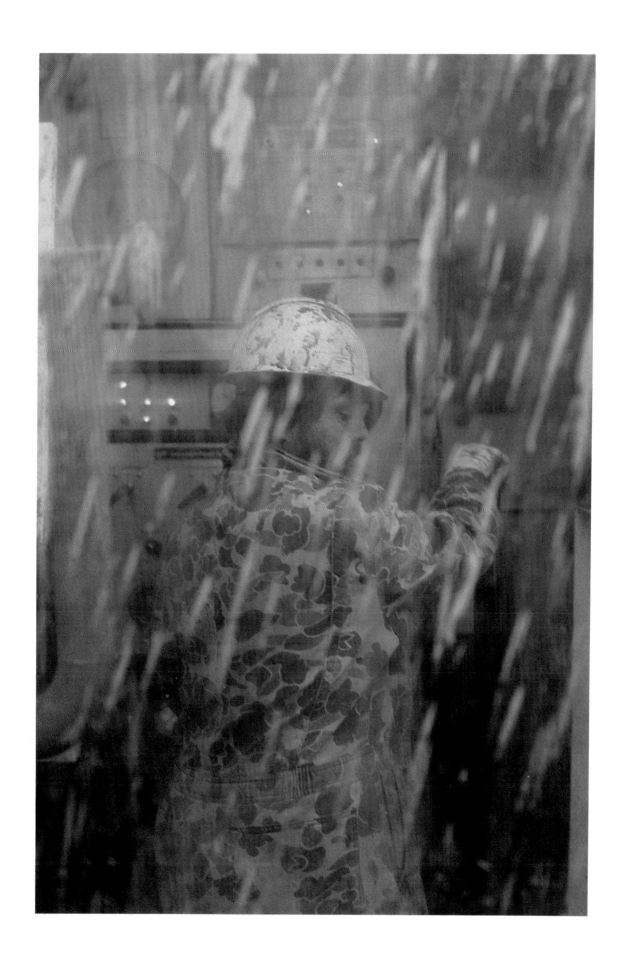

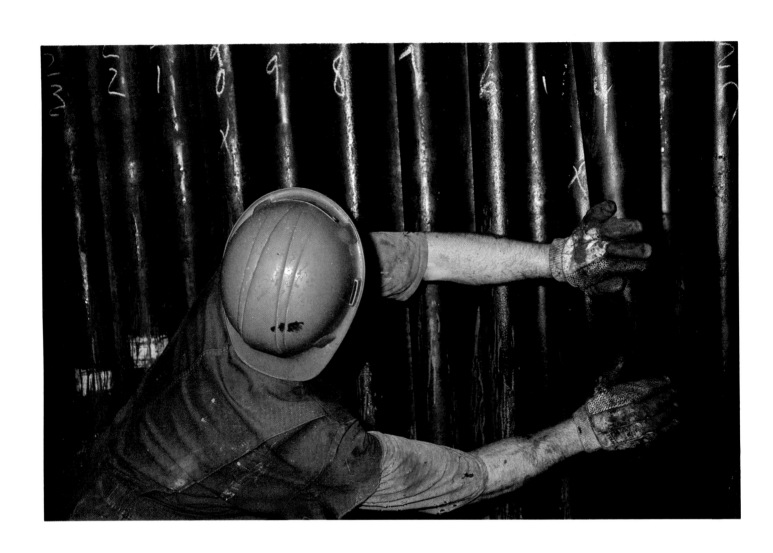

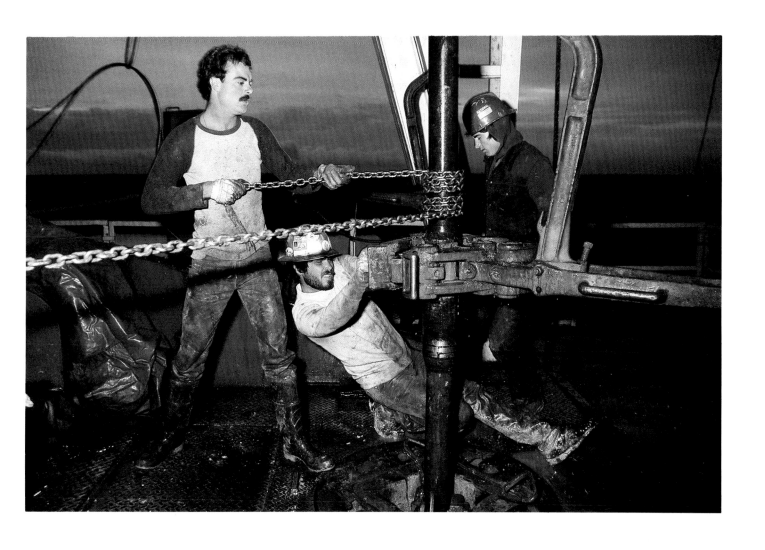

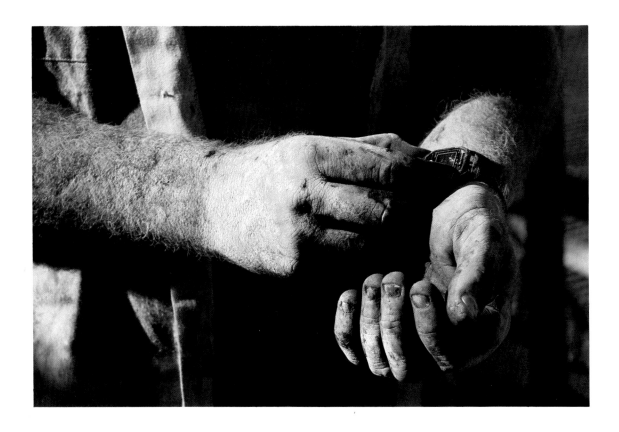

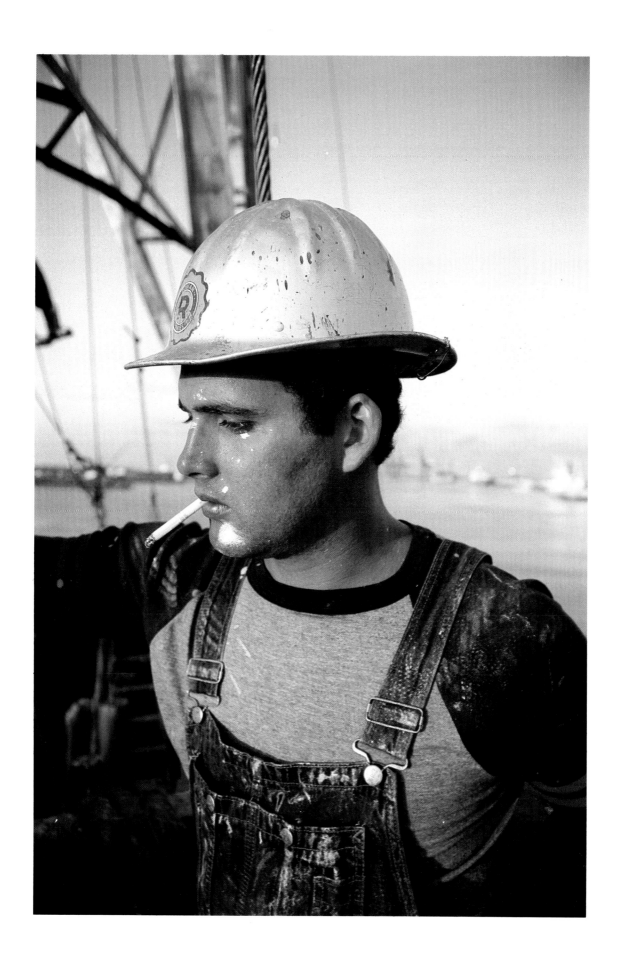

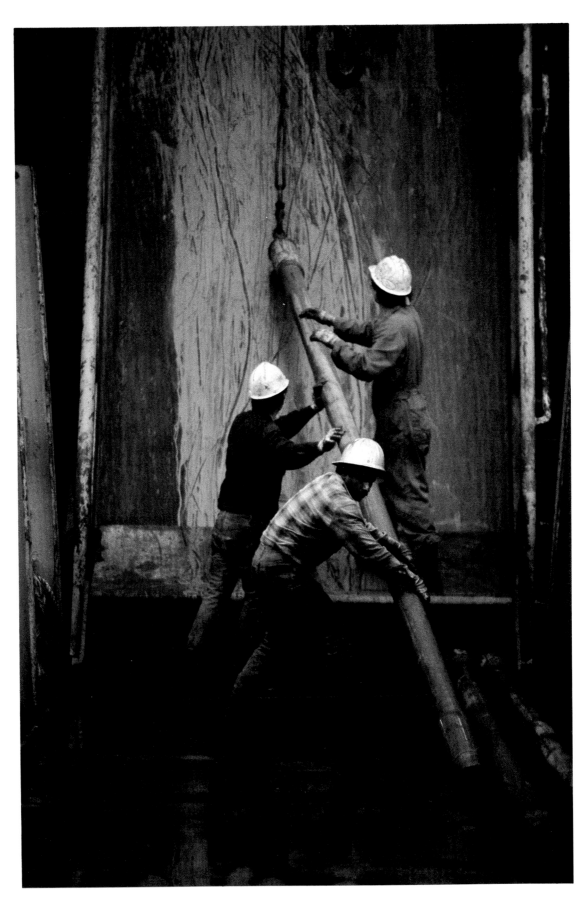

DRILLSHIP, SEVEN SEAS DISCOVERER

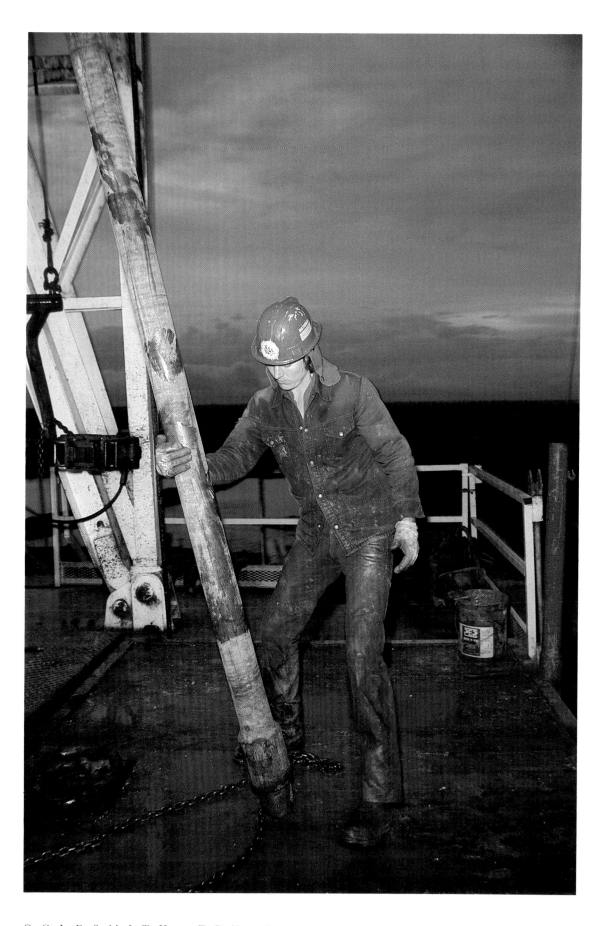

GOLDSMITH, TEXAS

"It's hard work. It never rains, it never snows, it never gets cold out there. You go right on with your work just like it was all pleasant weather."

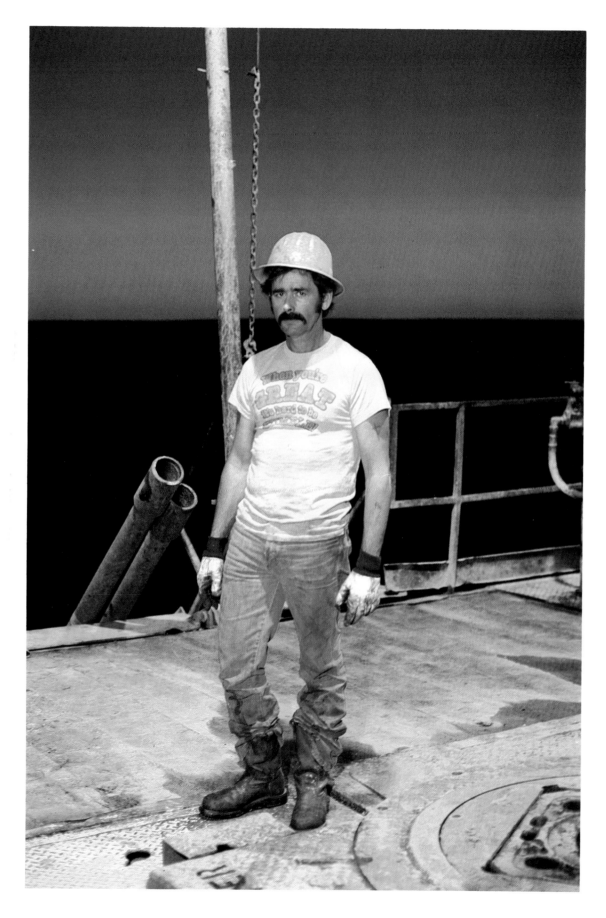

"What I do like is the outdoors and the people, the friendship, the trust. You trust each other 'cause your life's depending on this guy, but Their craziness. The unpredictability. You can't predict it at all. It's always kind of exciting."

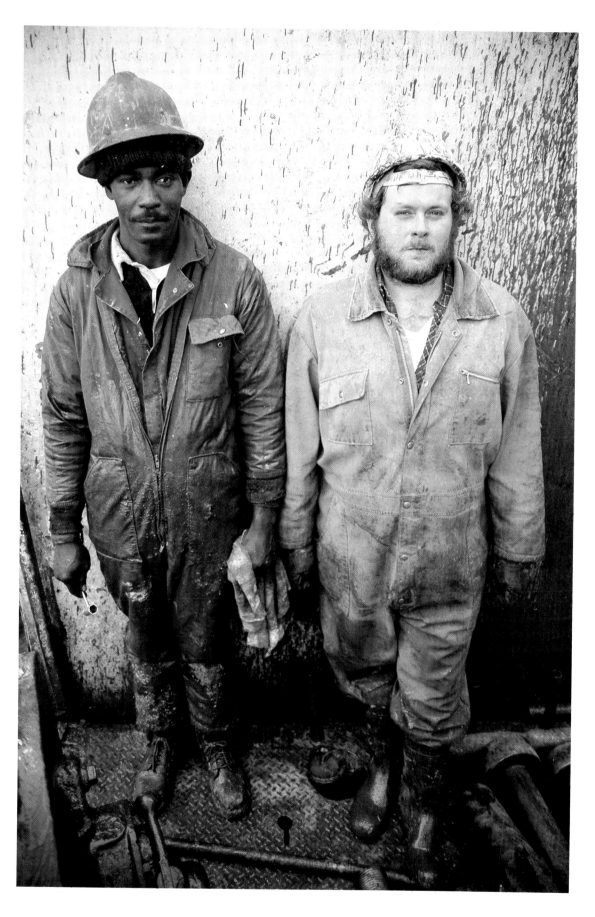

L A F A Y E T T E , L O U I S I A N A

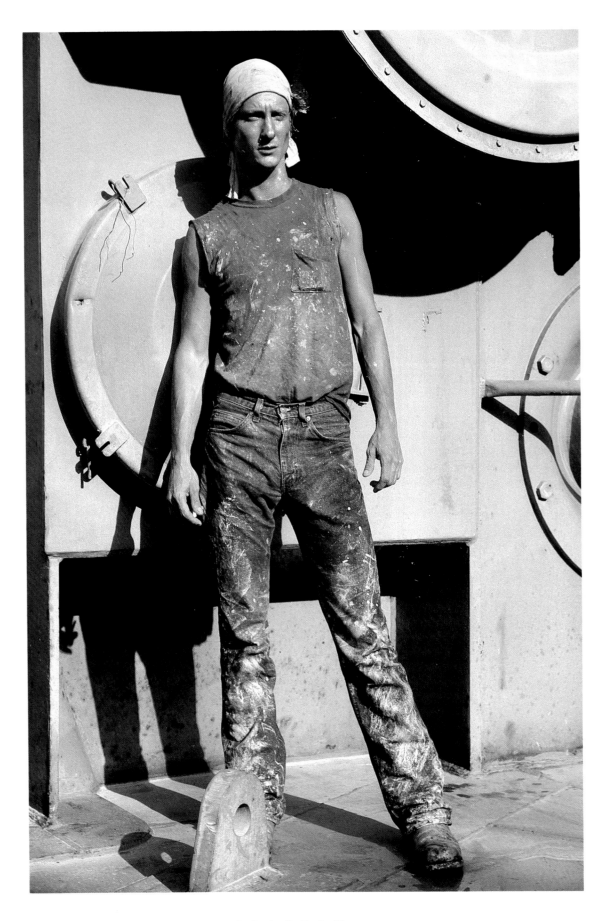

ROUGHNECK, GALVESTON

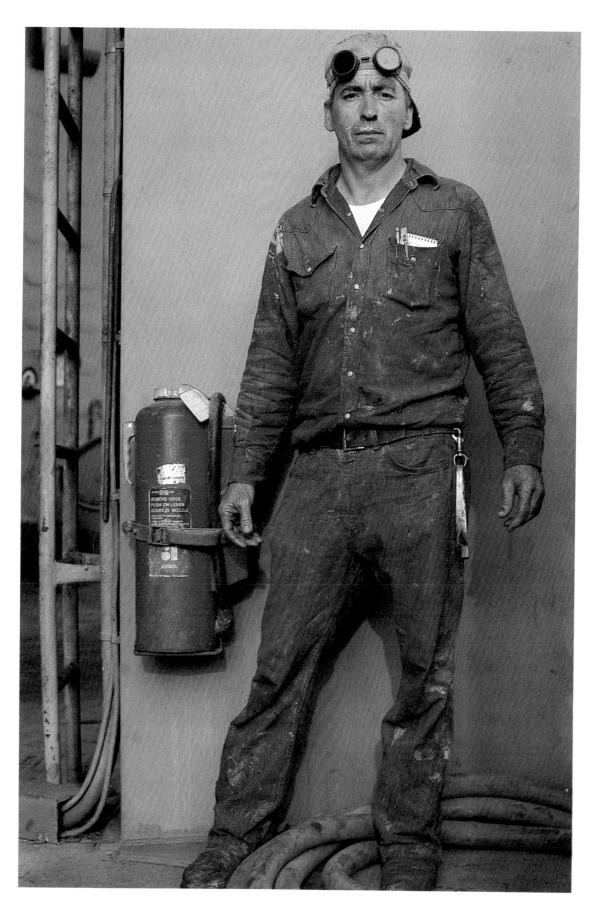

WELDER, GALVESTON

"What I like about it is getting up with the sun, and feeling my muscles. And working a day's pay and doing the best job I can. And when the sun goes down, that's when we get off work. Twelve hours."

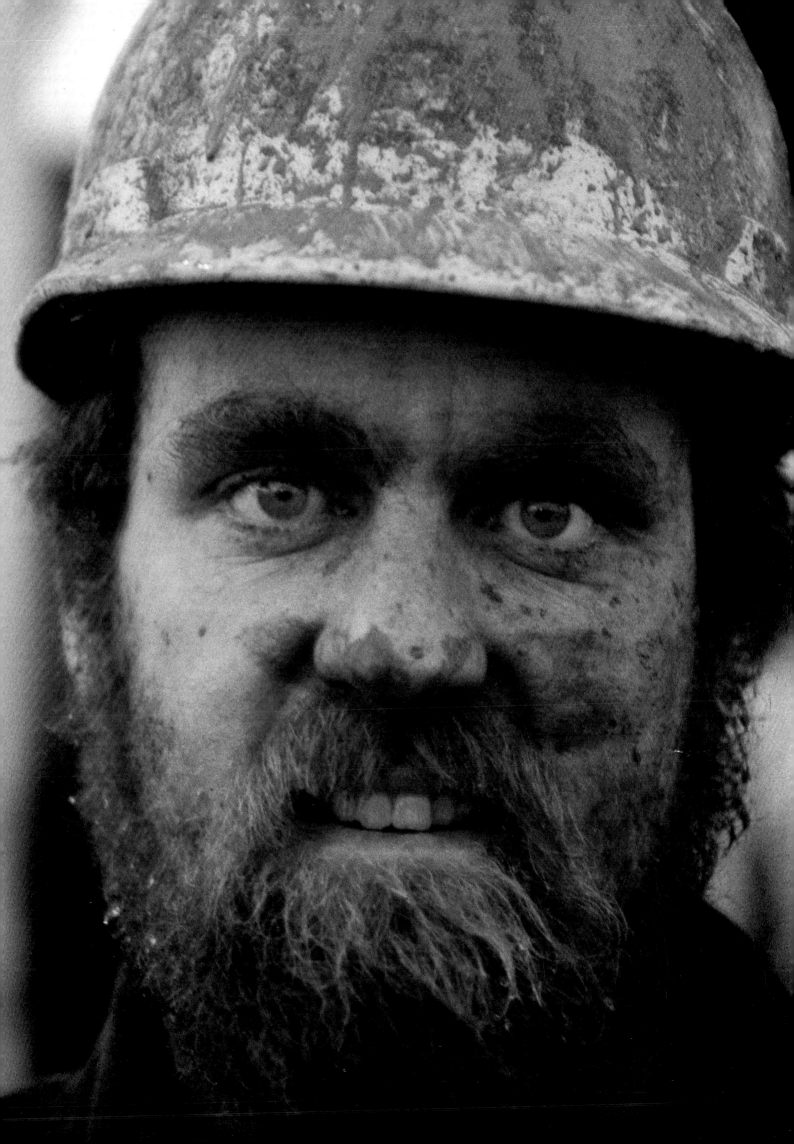

"Roughnecking is addictive. Oil gets in the blood. My granddaddy did it. My daddy did it. I can't quit.

When I worked building rigs it was fun for awhile. But it wasn't like tripping pipe. Tripping pipe is not a job. It's a sport."

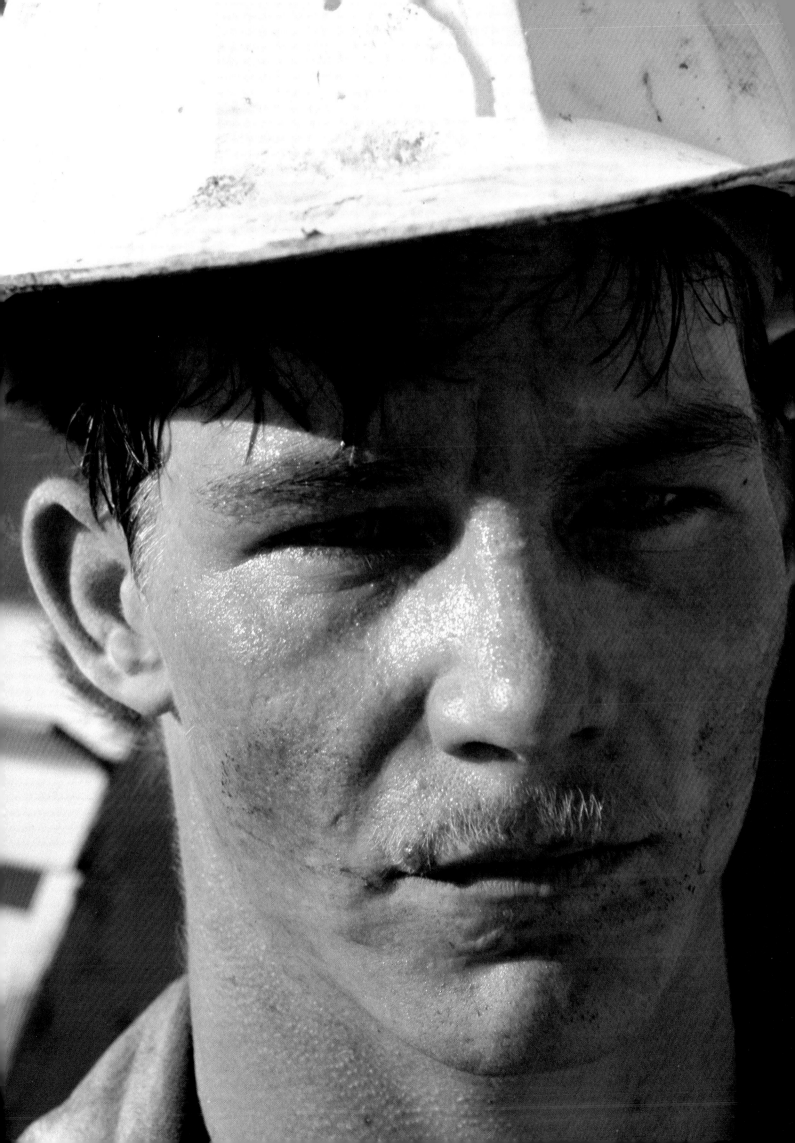

"This engineer on the offshore rig I was talking about, he come up to us and asked what time the morning paper was delivered. Me and a couple other boys got together, and we told him it came at 6:30 in the morning. That he should be on top of the helideck and the helicopter would drop by and throw you a paper. 6:30, boy he was up there trying to catch the goddamn paper. And there wasn't no paper. This fellow was a college boy, but he didn't have any of the facts as to what was going on."

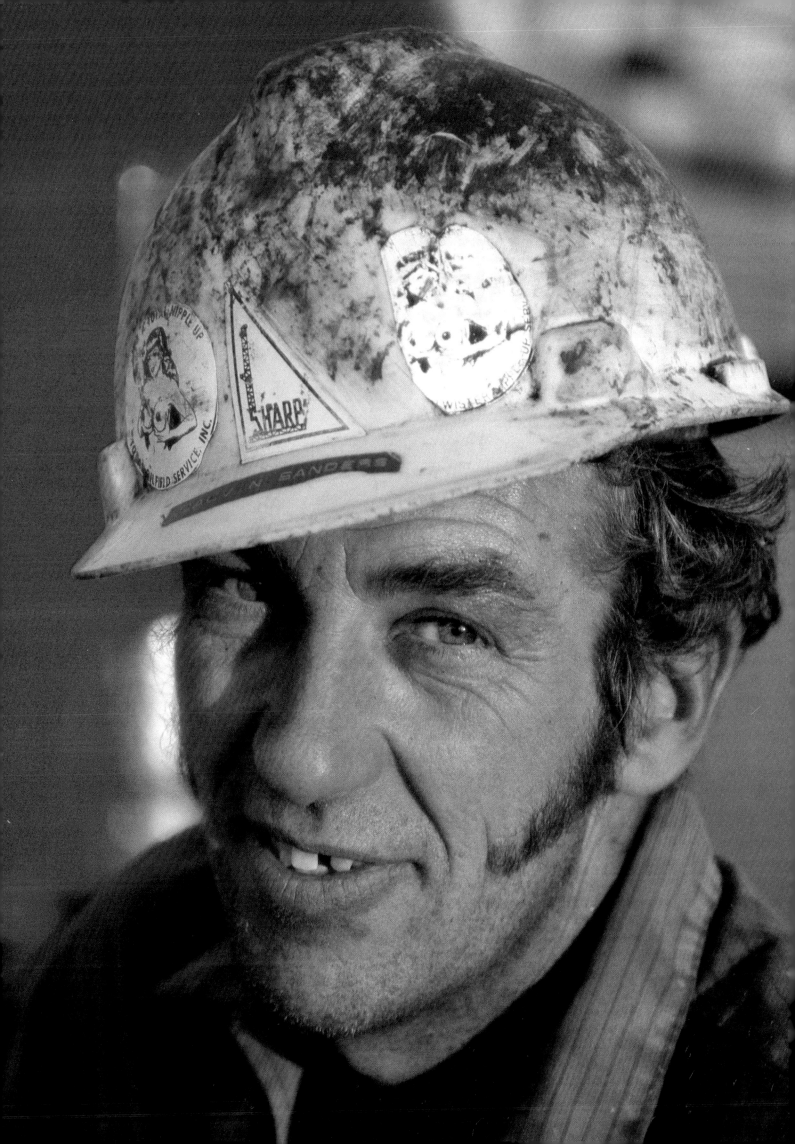

"When I'm at home I go fishing a lot. I just go there and cast and daydream. I don't like to think about the rig, but it always creeps in. Some joke we pulled here or a little thing we did there. You see a bump or a bruise and you go, 'Oh, the rig. Yeah.' It's always in the back of your mind."

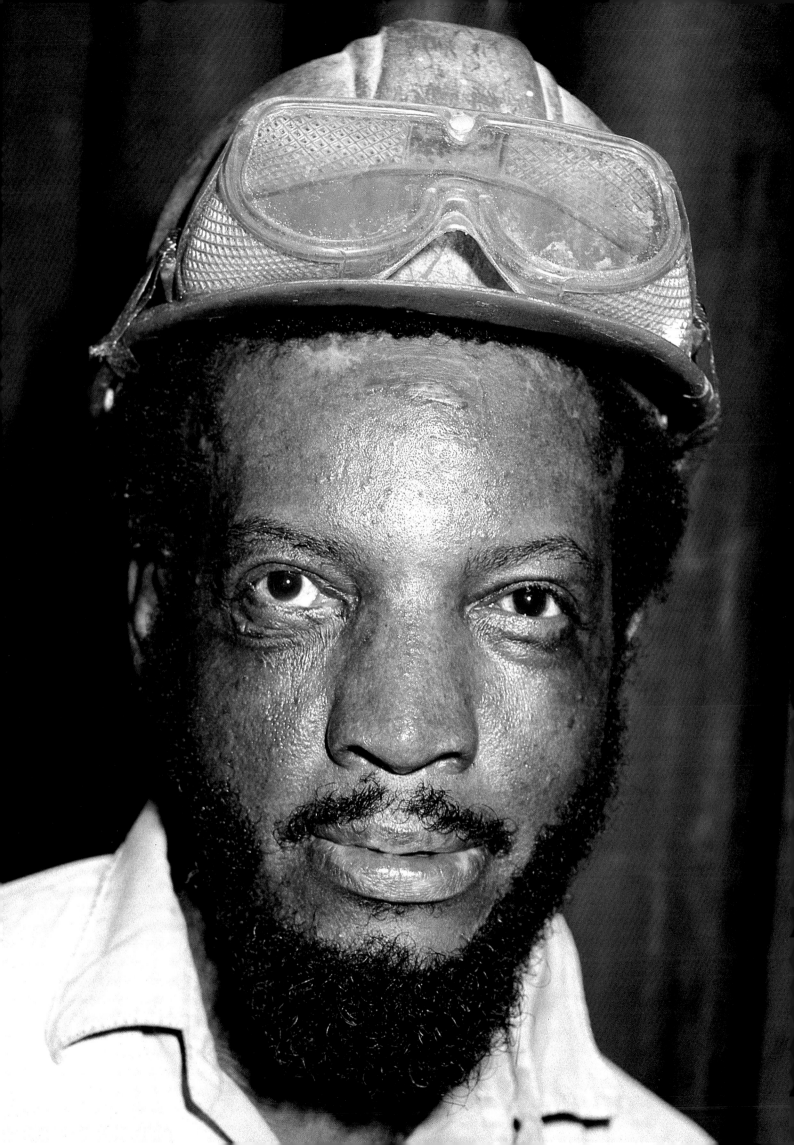

"I remember my dad used to say, 'See that rig there? Stay in school, you son-of-a-bitch.'"

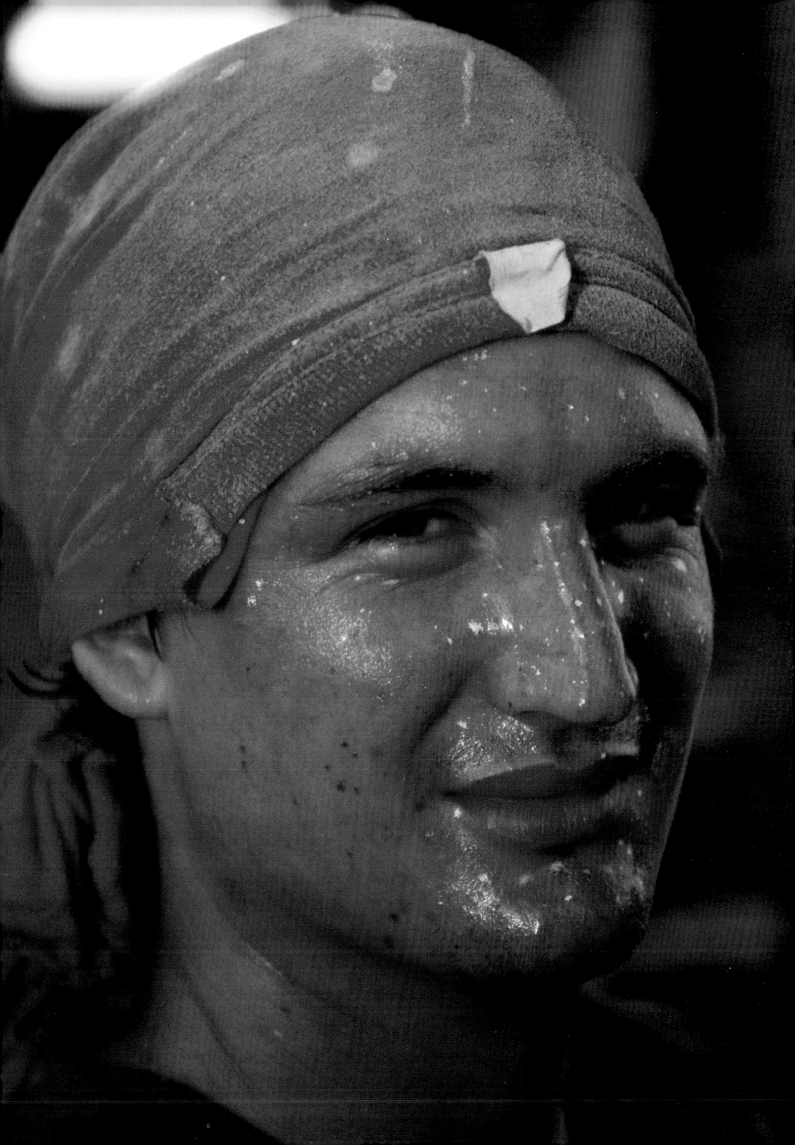

"I've tried to get my boys to work in different things. They've got good schooling, but they won't trade. They won't leave the oilfields for nothing. 'Cause it's their glory. It really is."

ROUGHNECKS' MOTHER

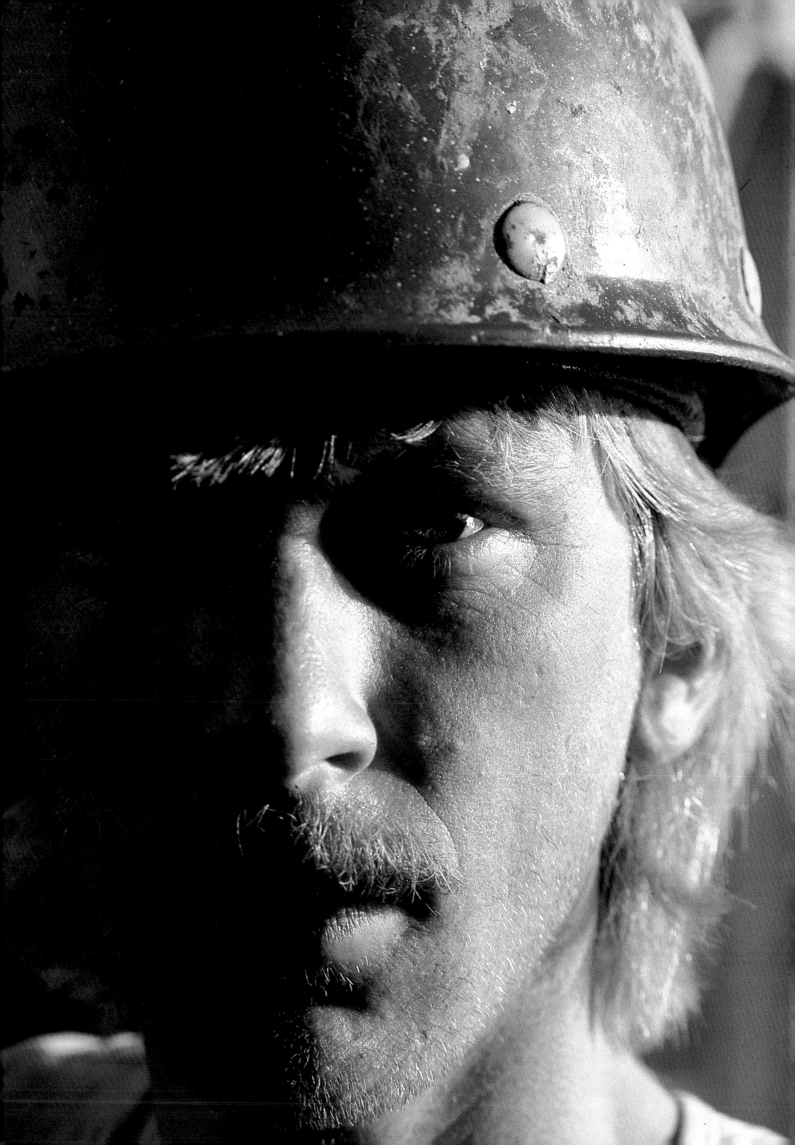

"You can't tell nobody what it's like out here. 'Cause it's different, everyday."

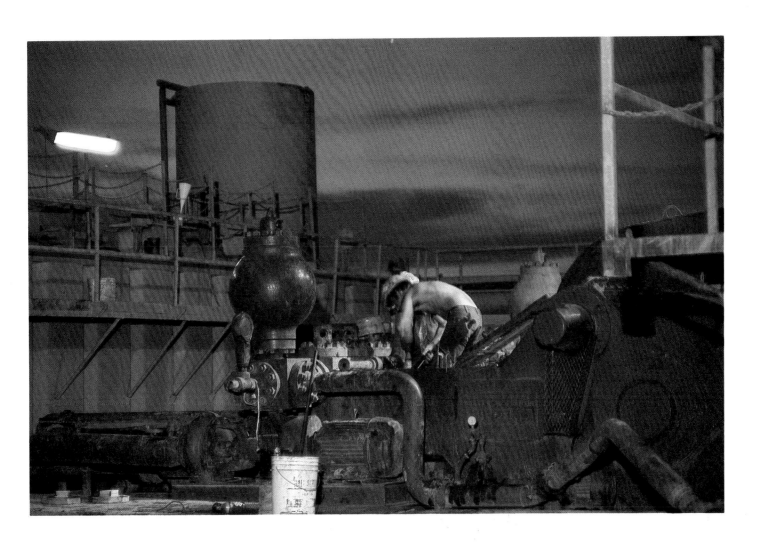

TWISTING OFF

"We all just want to act kind of natural. We don't want to act like goody-two-shoes or nothing like that."

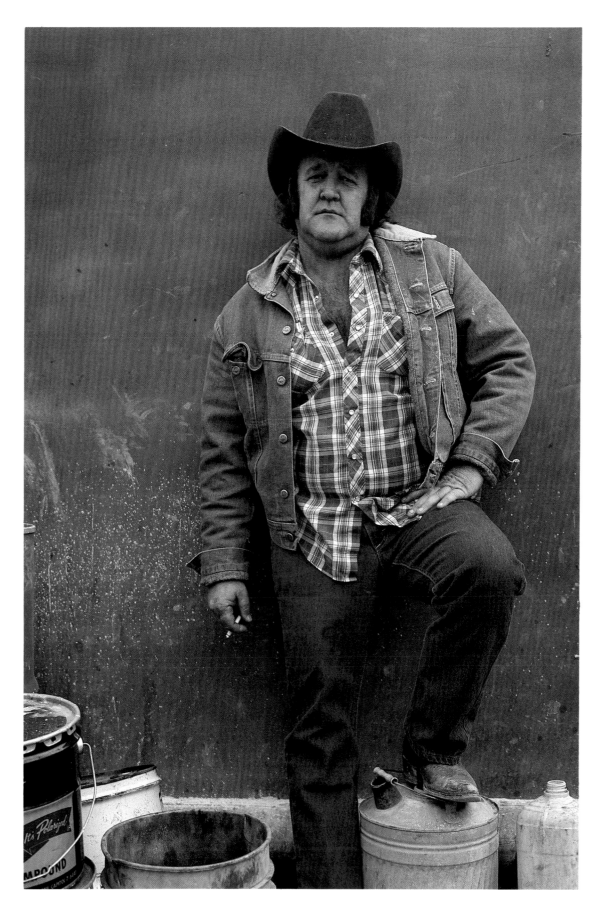

E R N E S T , D R I L L E R , V A L E N T I N E , L O U I S I A N A

"A lot of them drillers and tool pushers do their hiring in the bars, because they know that's where the hands stay when they ain't working."

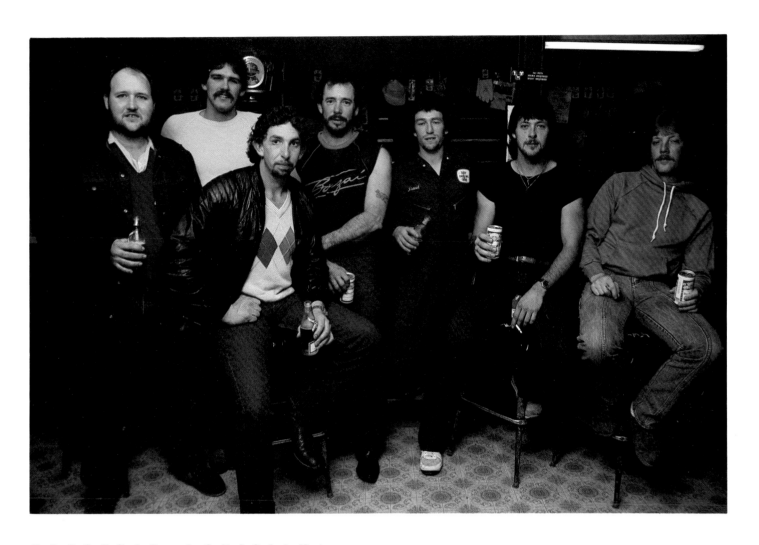

COCODRIE, LOUISIANA

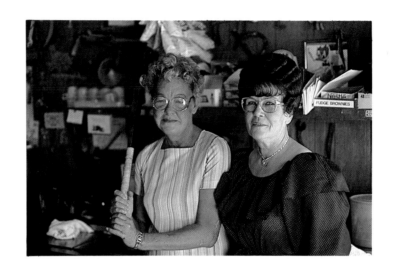

LOIS AND BETTY LOU

"If they're not in jail, they can't pay their rent. And if they can pay their rent they can't eat, 'cause they can't do all three at once. And if they eat, they can't pay their bar-tab. So it ends up that whoever is the bartender feeds 'em, clothes 'em, keeps 'em out of the jail, and hopes to hell they work enough to pay her back."

BETTY LOU

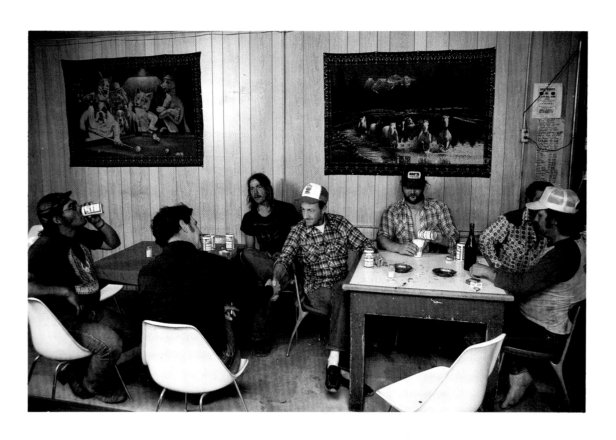

BETTY LOU'S PLACE, BIG SPRING, TEXAS

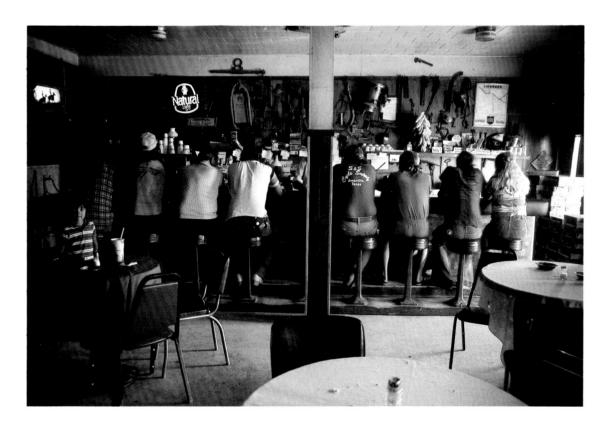

BETTY LOU'S PLACE, BIG SPRING, TEXAS

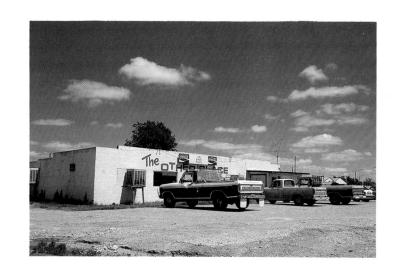

"Sure, we go to them honky-tonks. And if somebody wants to fight, hell yeah, we'll fight. You can fight a son-of-a-bitch, get up and shake hands, go drink a beer and forget about it. The next night you might run into him again and he'll be helping you fight over something else."

ROUGHNECK

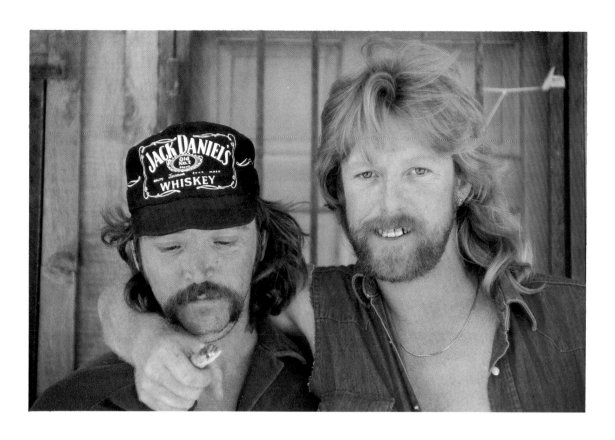

ROUGHNECKS, BIG SPRING, TEXAS

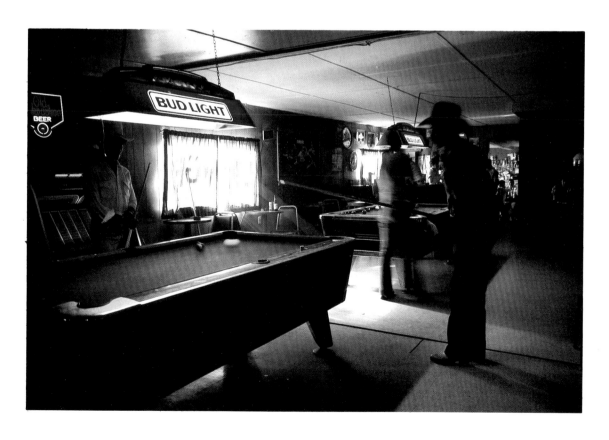

MARINA BAR, CANEY CITY, EAST TEXAS

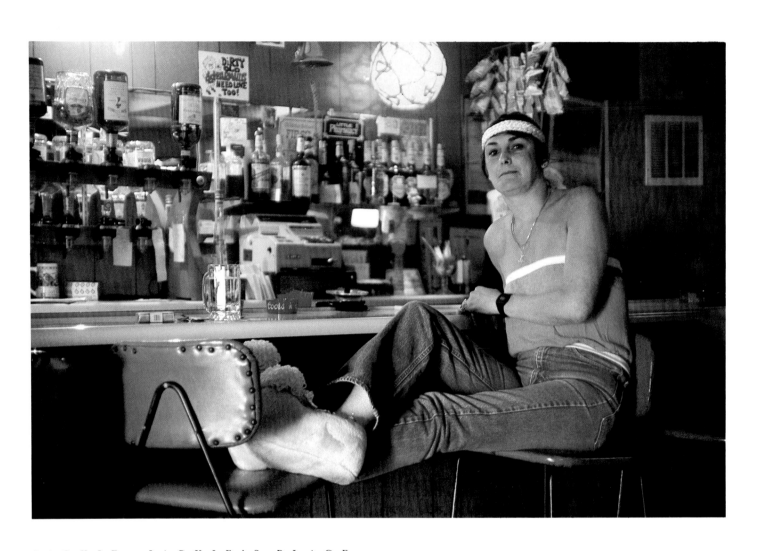

JACKIE, JACKIE'S PLACE
GALVESTON, TEXAS

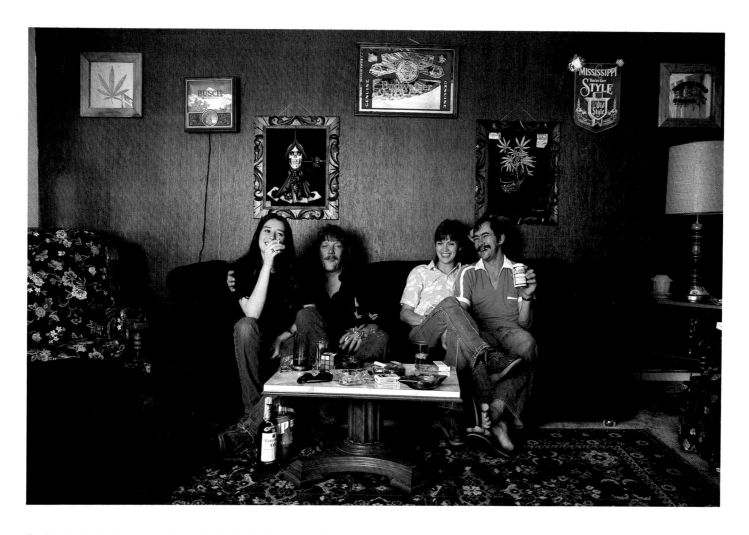

ROCKY'S APARTMENT, HOUMA, LOUISIANA

"Roughnecks are just like anybody else. They get drunk and raise hell. Now maybe they raise a little more hell than most."

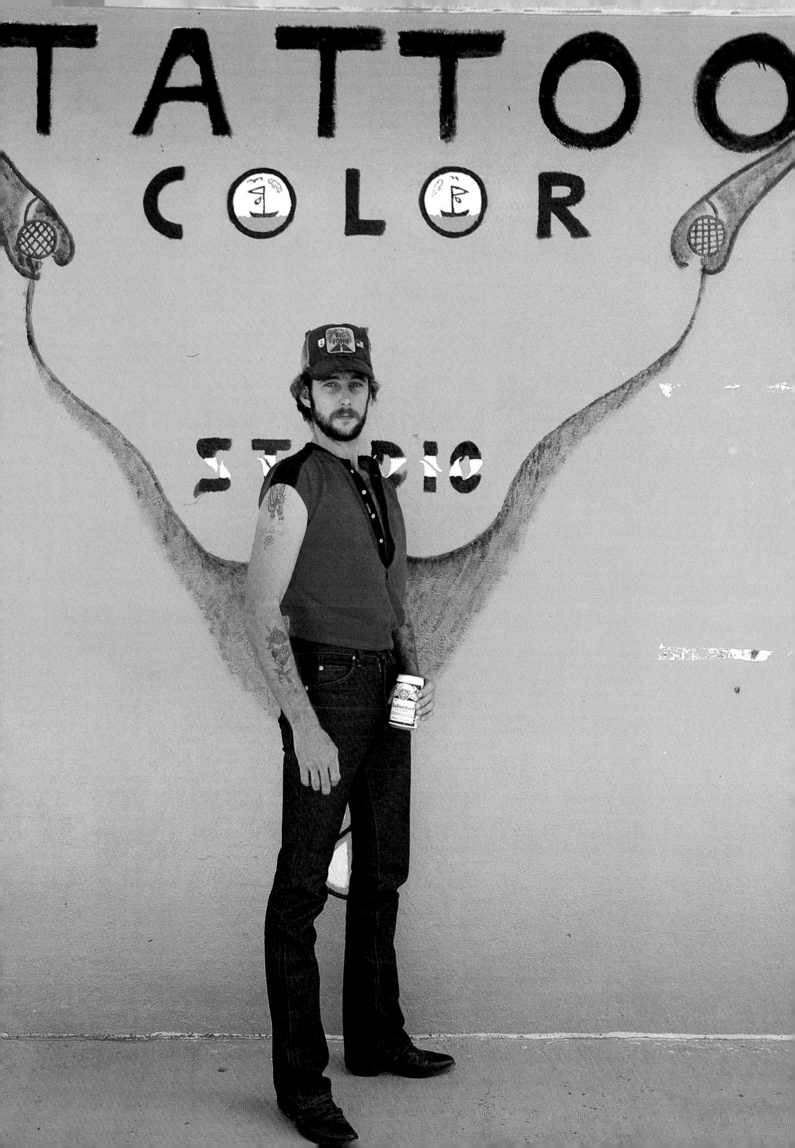

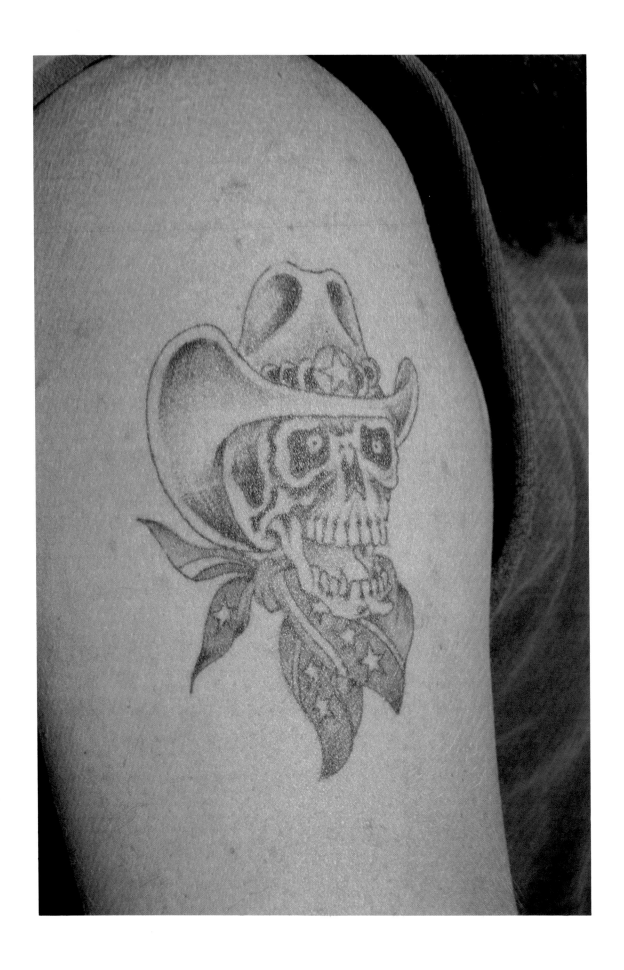

127

"The roughnecks are a breed of their own. They don't mix very well."

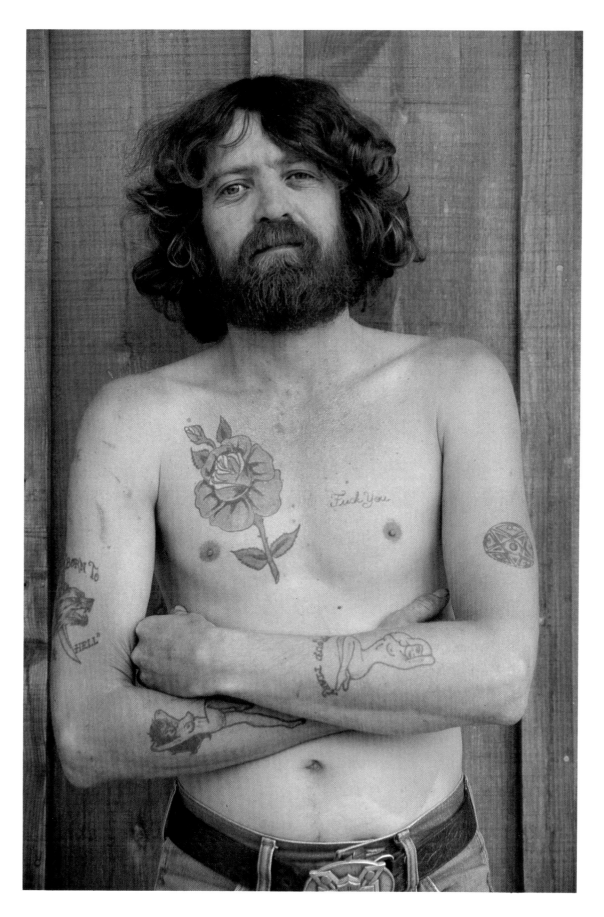

BIG SPRING, TEXAS

"They have a tendency that when they get off they like to go down to Mexico. Most of them like to go to Acuña. Juarez is just about as close. But Acuña, at least back in my younger days, was a better place to go. They had a better line of whores."

BOY'S TOWN, NUEVO LAREDO, MEXICO

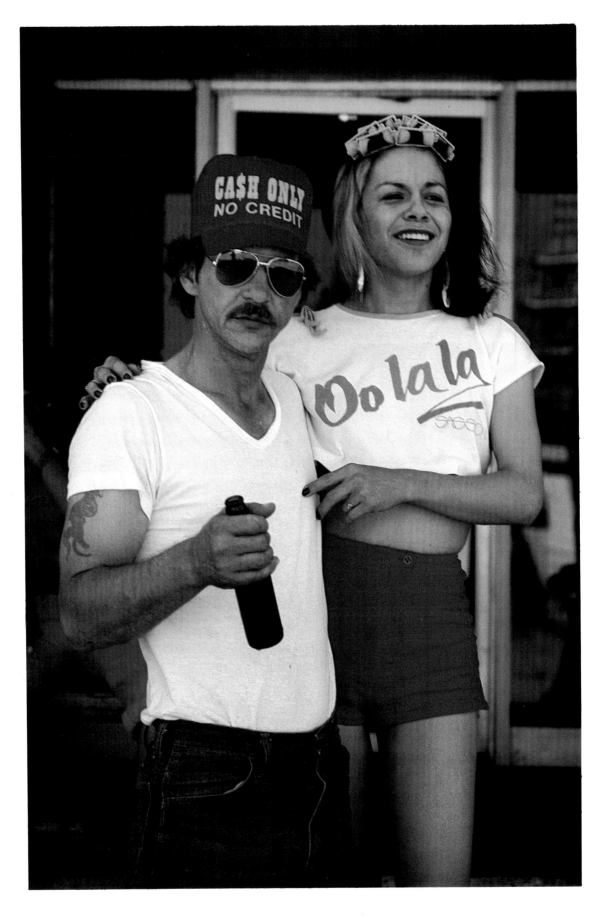

ROUGHNECK AND ACOMPAÑERA

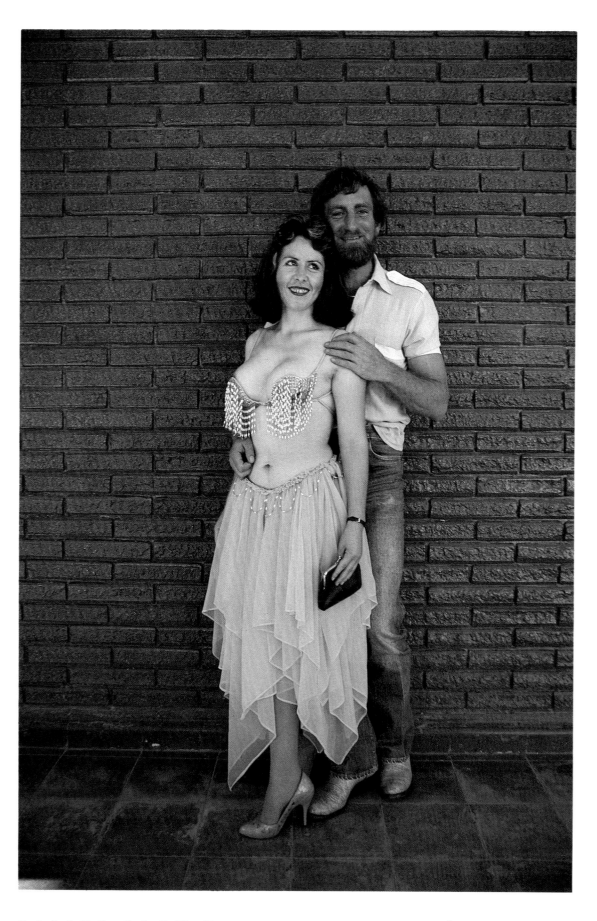

CASING CREW HAND AND ACOMPAÑERA

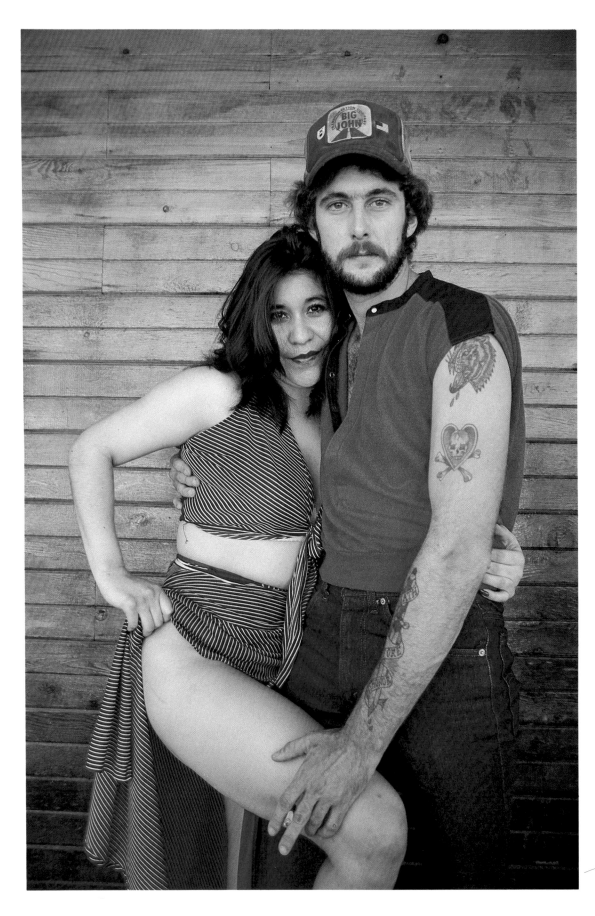

CASING CREW HAND AND ACOMPAÑERA

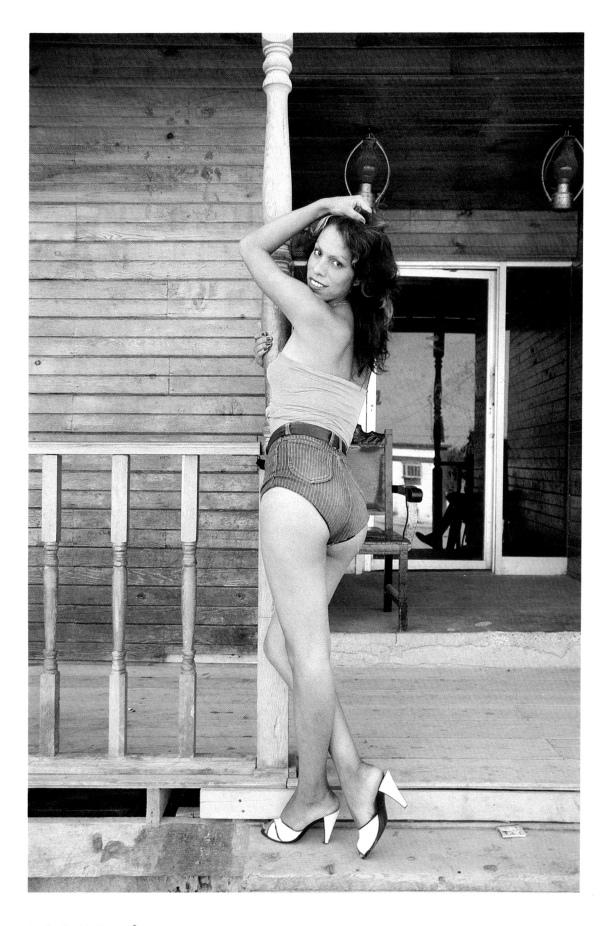

ACOMPAÑERA

"The roughnecks are the regular customers. They're all real down to earth. I think they're the nicest people 'cause they don't come in all stuck up. They're the ones that the business is really built on."

TOPLESS DANCER

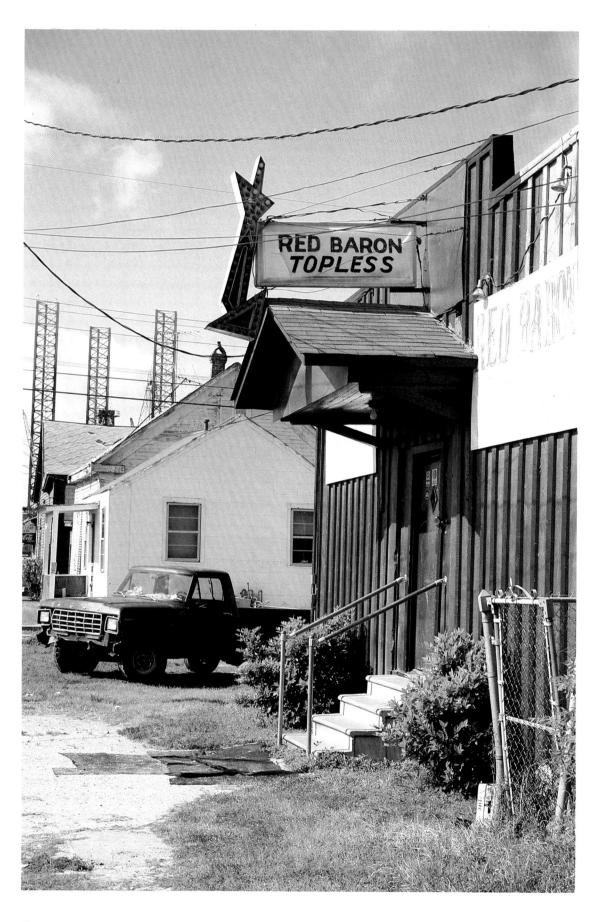

GALVESTON, TEXAS

"They probably got an old lady sittin' at the house that's meaner than they are. And they see your picture in that book, and one of 'ems gonna get a whuppin."

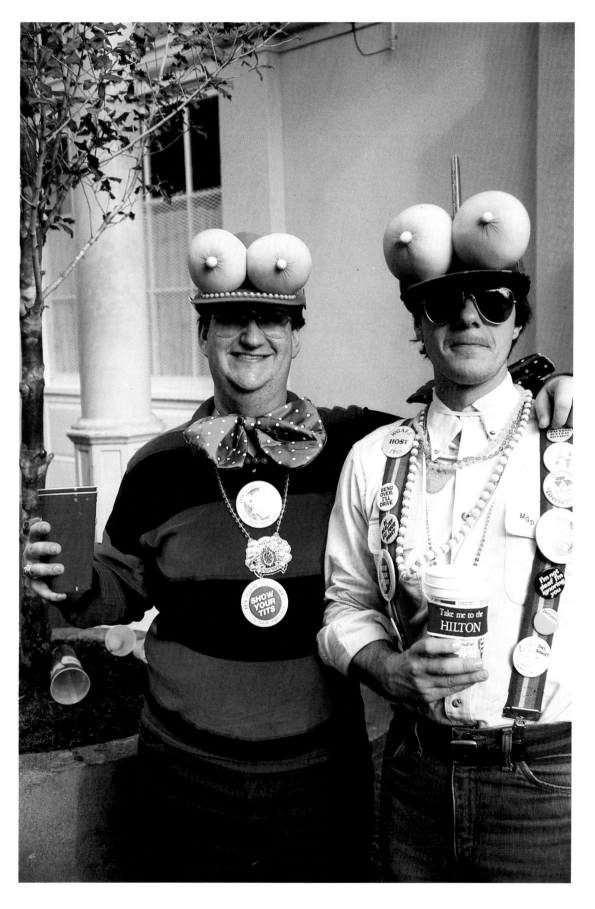

OILFIELD ACCOUNTANTS, MARDI GRAS

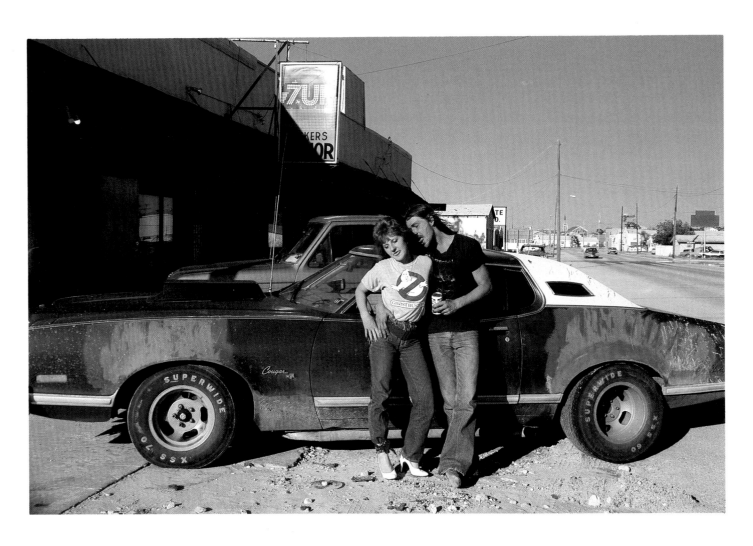

BIG SPRING, TEXAS

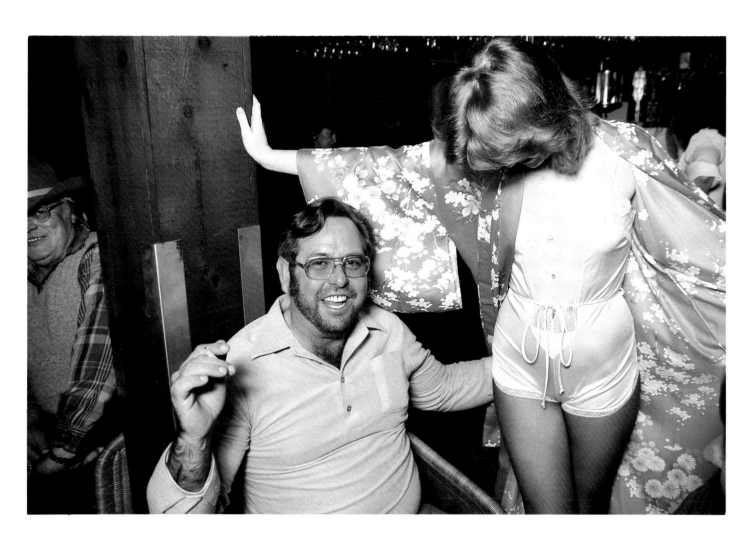

LINGERIE SHOW, HOLIDAY INN
LAFAYETTE, LOUISIANA

"It's a lot easier to talk them into jail than to wrassle them into jail."

DEPUTY

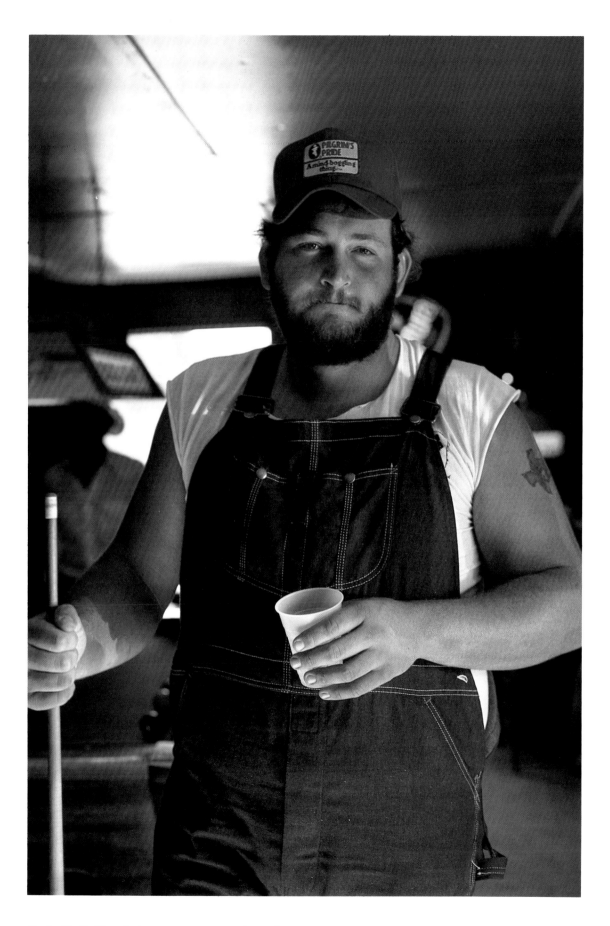

CANEY CITY, TEXAS

"The calls would come and they'd say this fellow's stacking the Yellow Rose beer joint down here, take the artillery and go in after him. He was a roughneck and win or lose, he'd end up with a pile of peace officers in the middle of the floor. And he'd stay and wait for them to come around so they could take him off to jail. He just felt like he had a point to make, and he did a pretty good job of it."

ECTOR COUNTY DEPUTY

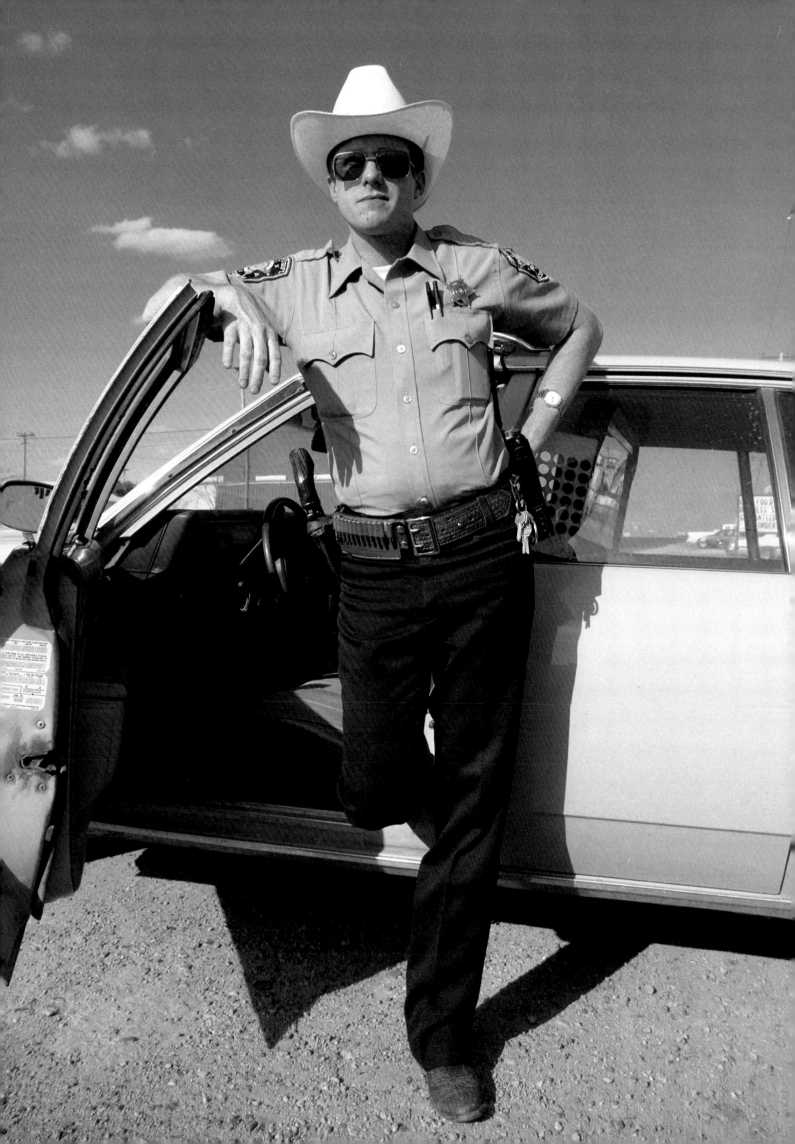

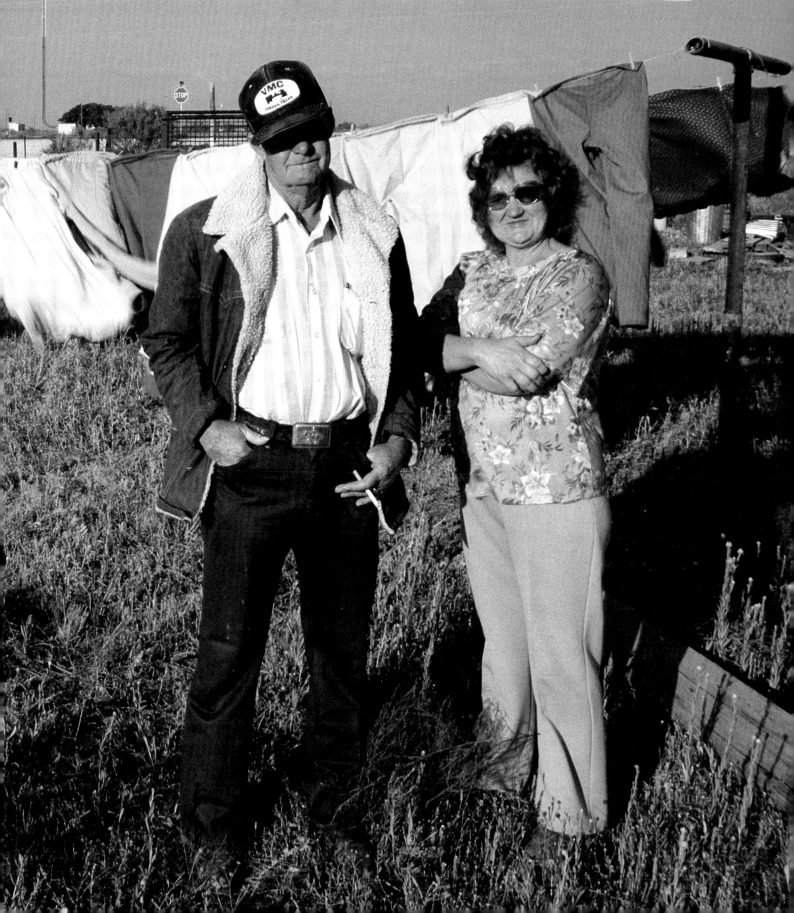

HEART AND PRIDE

"You know what they say about the oil-field. You got to have a weak mind and a strong back to stay in it. That's oilfield talk."

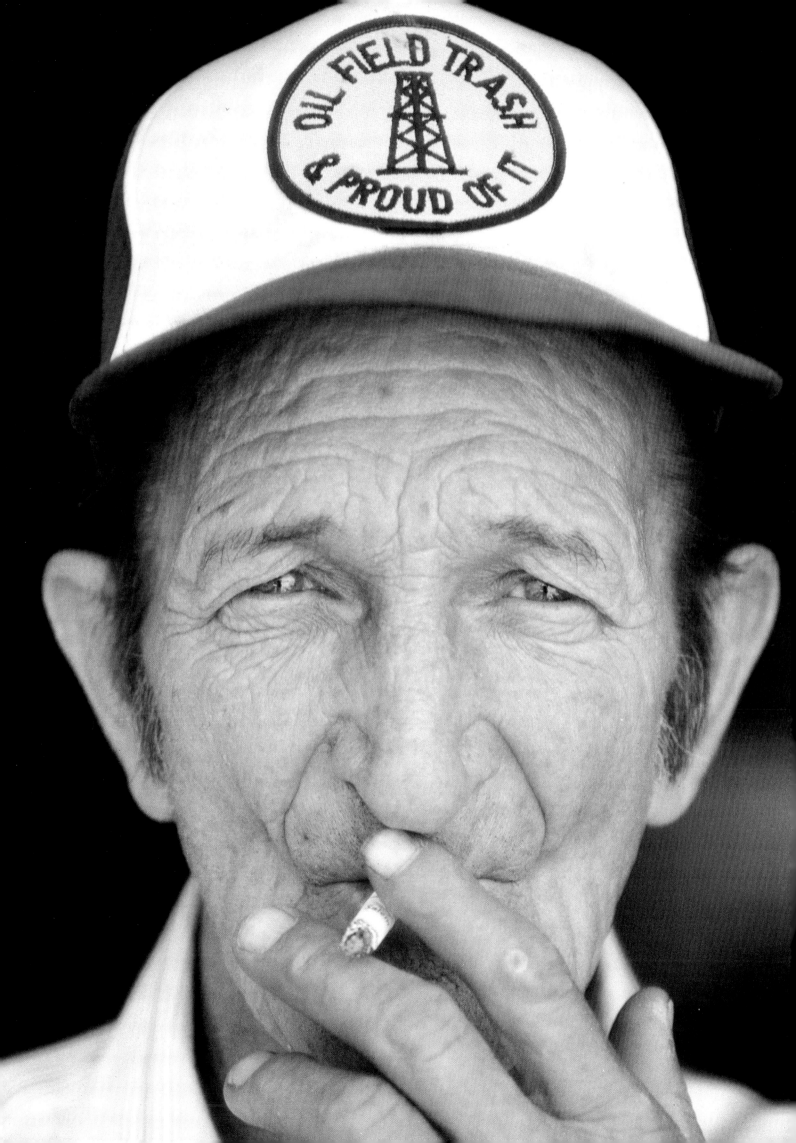

"That Thanksgiving, when this son right here was sixteen, his father was supposed to go out and pick up his crew. He was a driller then, and he found one or two men that wasn't drunk that were ready to go out. Then he came back to my son and he said, 'Would you like to go out with us today? I'll show you how it's done.' And from then on, I couldn't even keep him in school, he loved the oilfields so well. And the same with this one. He started when he was sixteen too. They really like it, and they both got nice families and homes and everything."

BONNIE SMITH

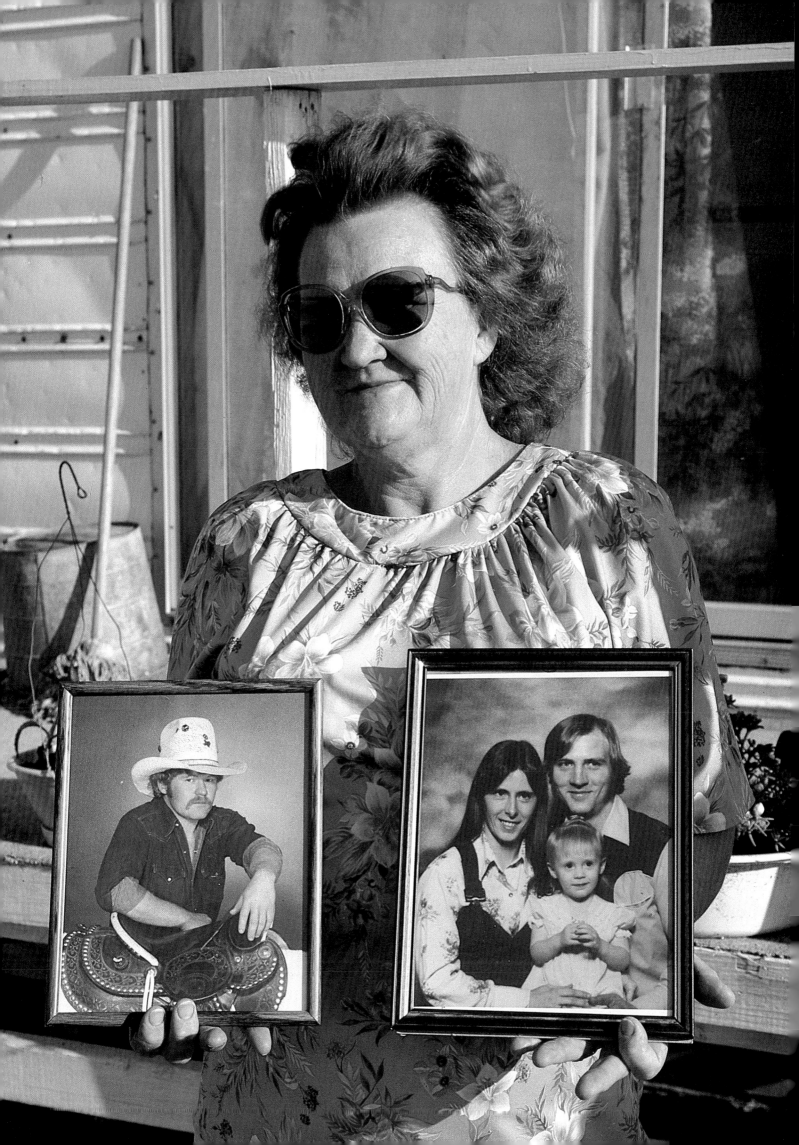

"Sometimes being married to a guy who works in the oilfield is so aggravating because he doesn't know from one day to the next if he's gonna' be coming home. It's kind of scarey. A lot of times I can't get used to it.

He doesn't like to bring his job home. And he doesn't like to bring his home to his job. But sometimes, it just can't be helped.

I've tried to get him to do something else, and he won't. He did start at the very bottom, and he's climbed up this far. And I imagine he'll climb up a little farther before it's all over.

Sometimes we stay home two or three weeks without seeing him. Alone, while he's out working. That's one of the things we got to get used to."

DRILLER'S WIFE

"It draws children to their daddy. They miss him, they get so excited that's he's coming, and it's always like a reunion. It's great."

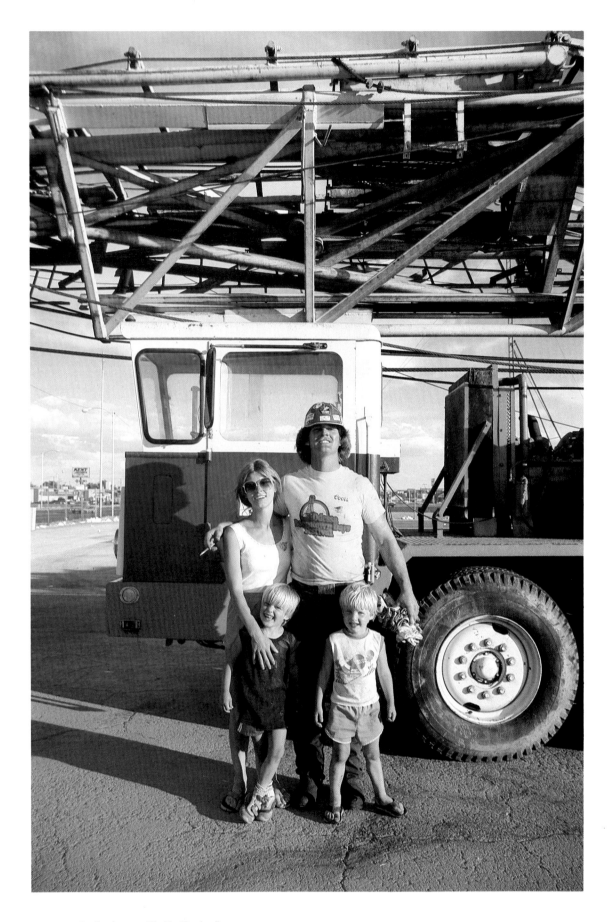

ODESSA, TEXAS

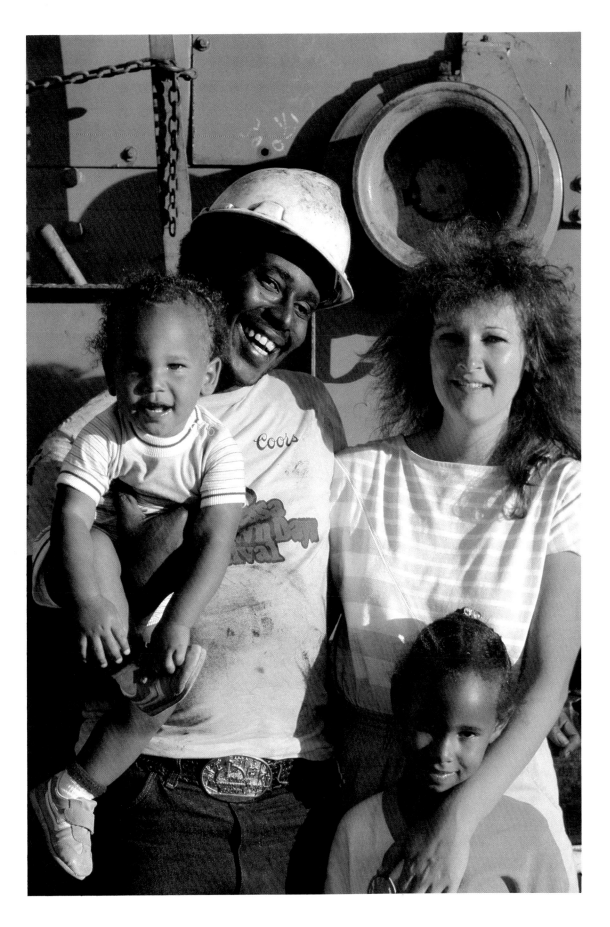

ODESSA, TEXAS

MABANK, TEXAS

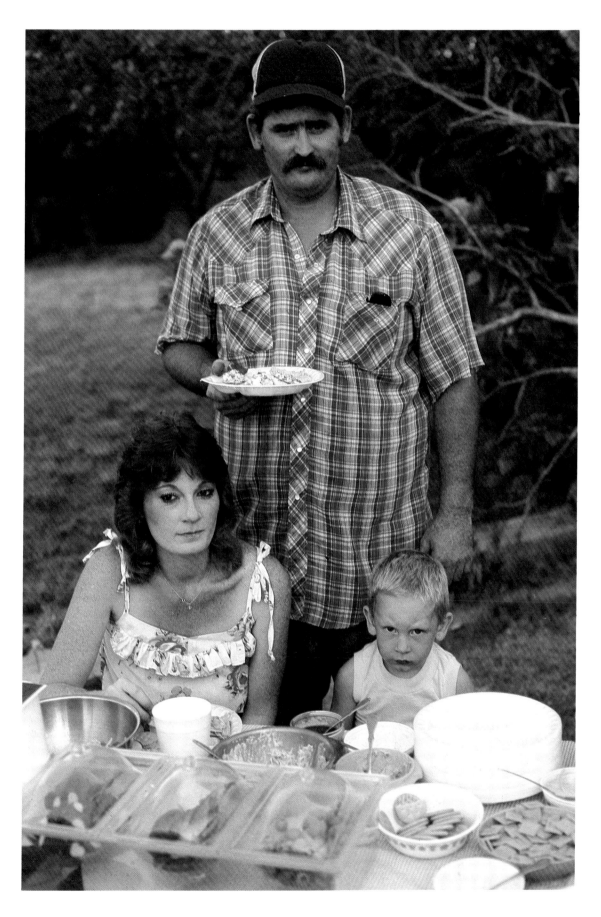

FOURTH OF JULY, KONAWA, OKLAHOMA

"When you're in the oilfield, if you're married, you got to take under consideration that you got your wife and your kids that you're gonna be away from for a long time sometime. If you want to stay with it, you go with the rig. That's it. Your wife and your kids gonna have to wait. Most of the time they will. Takes a pretty tough old gal, a good-hearted woman."

DRILLER

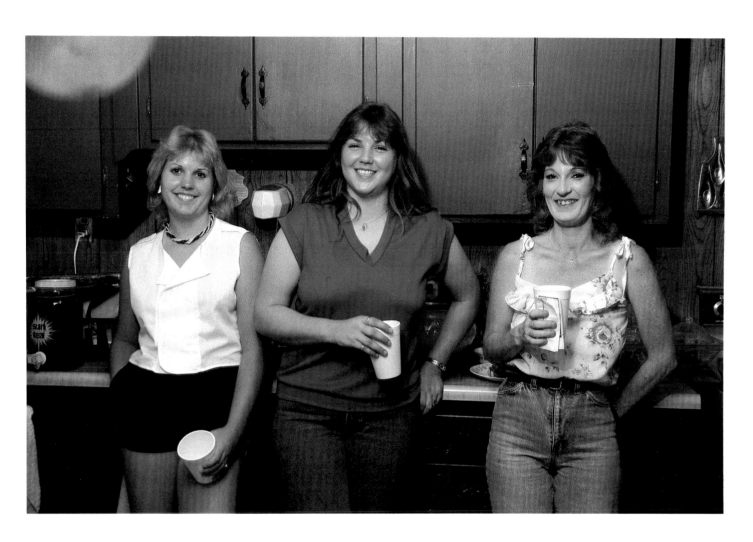

K O N A W A , O K L A H O M A

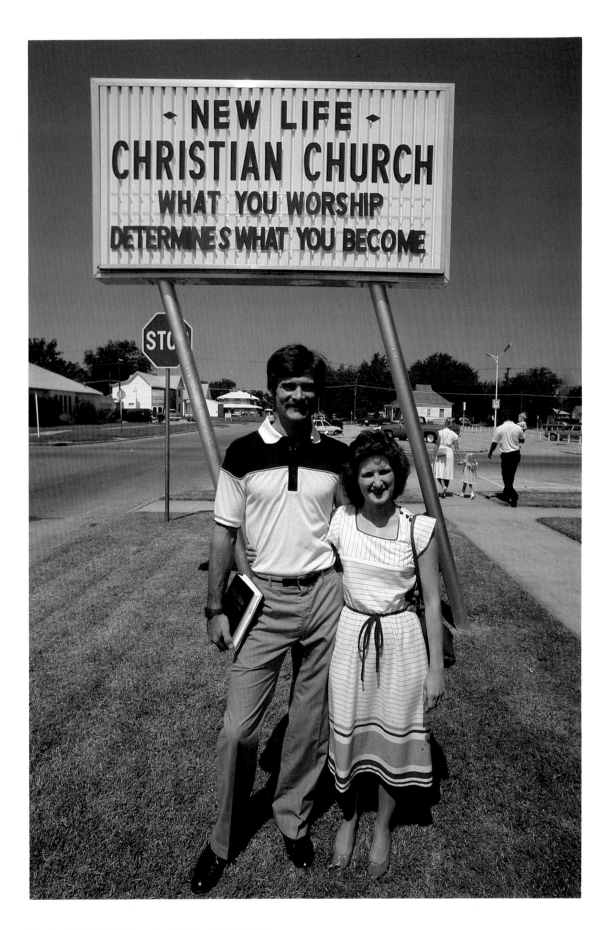

DRILLER AND WIFE

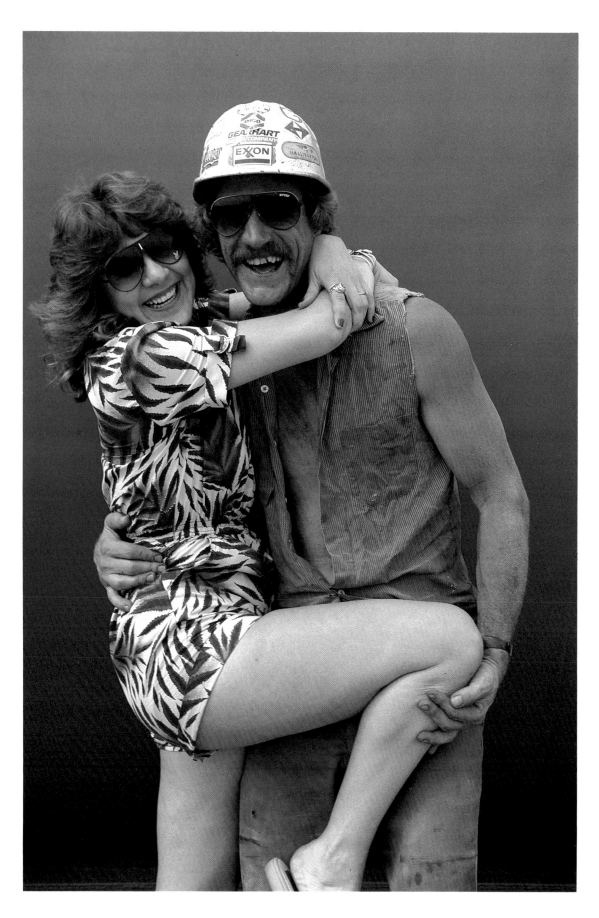

ROUGHNECK AND FIANCÉE

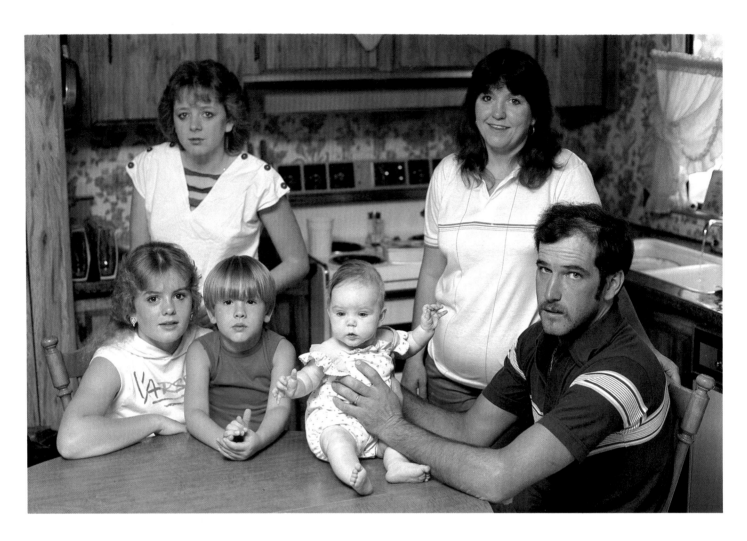

CANEY CITY, TEXAS

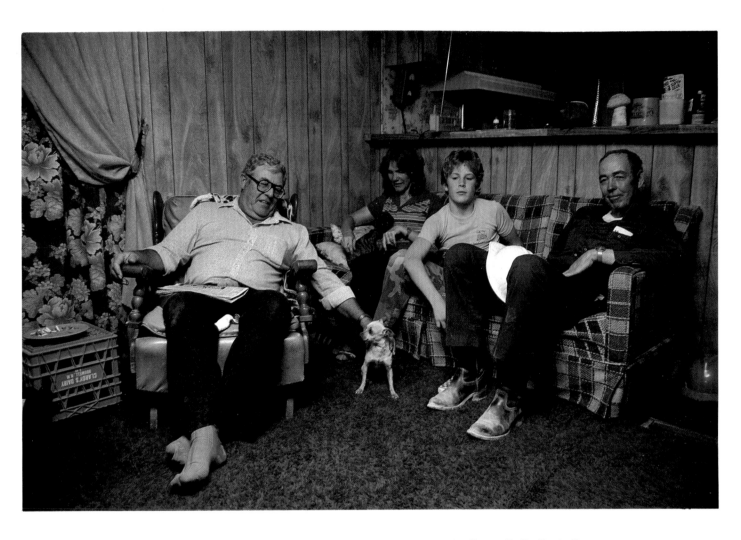

PUSHER'S TRAILER, ECTOR COUNTY, TEXAS

"This boy's lying in the hospital about half paralyzed. We just want him to know we're thinking about him all the time."

MARK

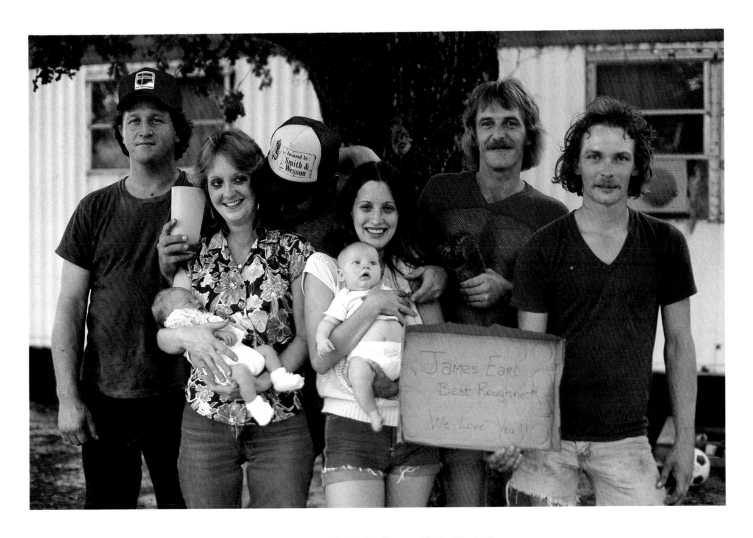

M A R K ' S B A R B E C U E , M A B A N K , T E X A S

"I understand life. I know that everybody wants something better for their kids. The same thing that happened with our parents and their parents, and on back."

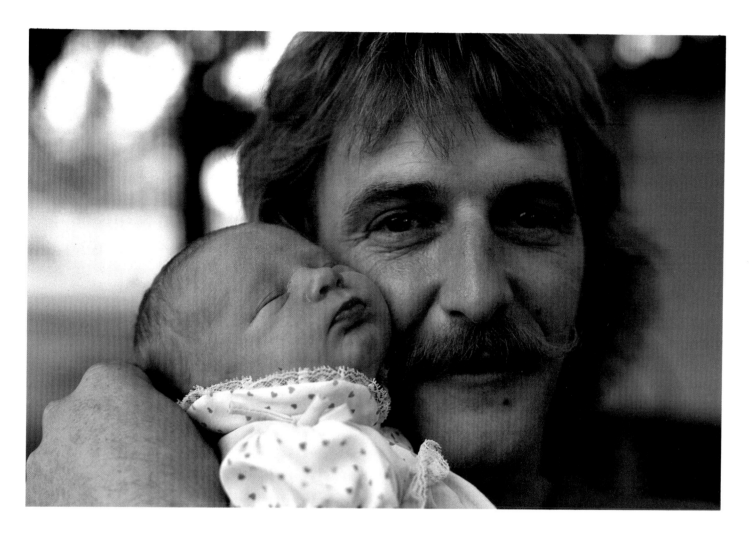

MABANK, TEXAS

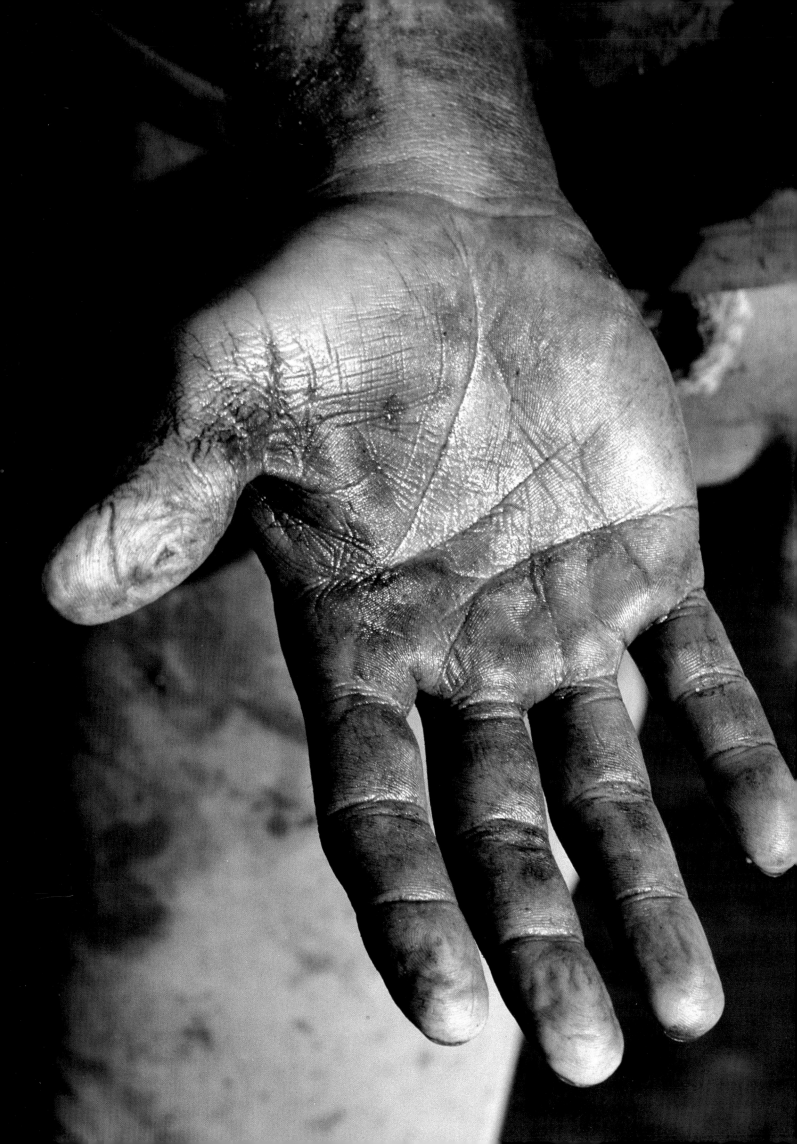

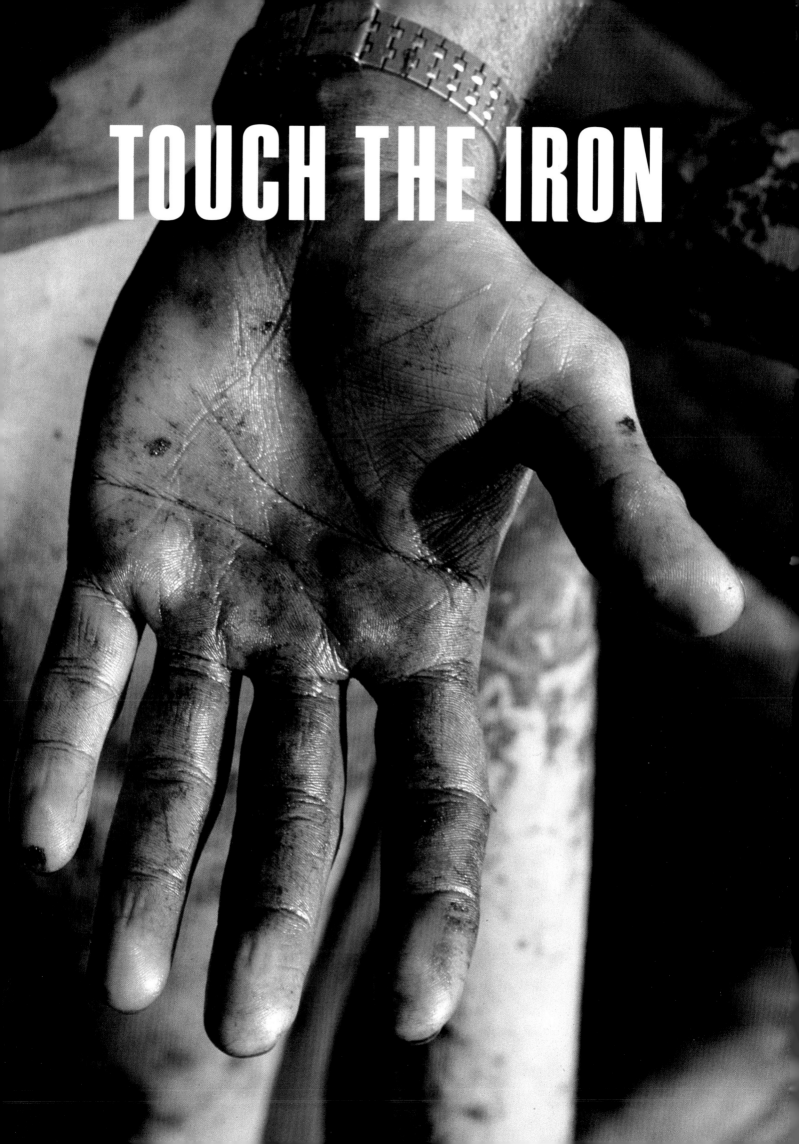

TOUCH THE IRON

"Even though he's retired now, he's got to have something to do with the iron. When he's out watching the rigs, he gets the urge and he climbs the steps and goes up to the derrick. He can't hardly keep from touching the iron."

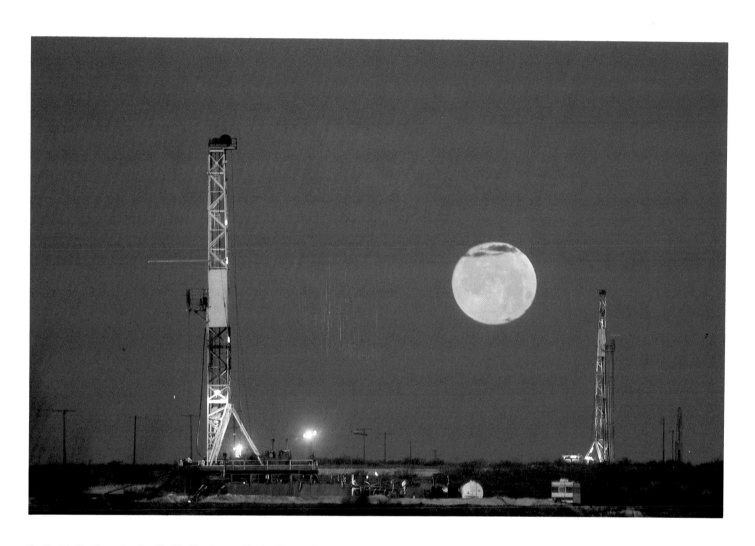

ECTOR COUNTY, TEXAS

"This thing here, it's a challenge. I went for that. I like the heavy equipment; how they move this big iron around; the ease and the speed that they do it with."

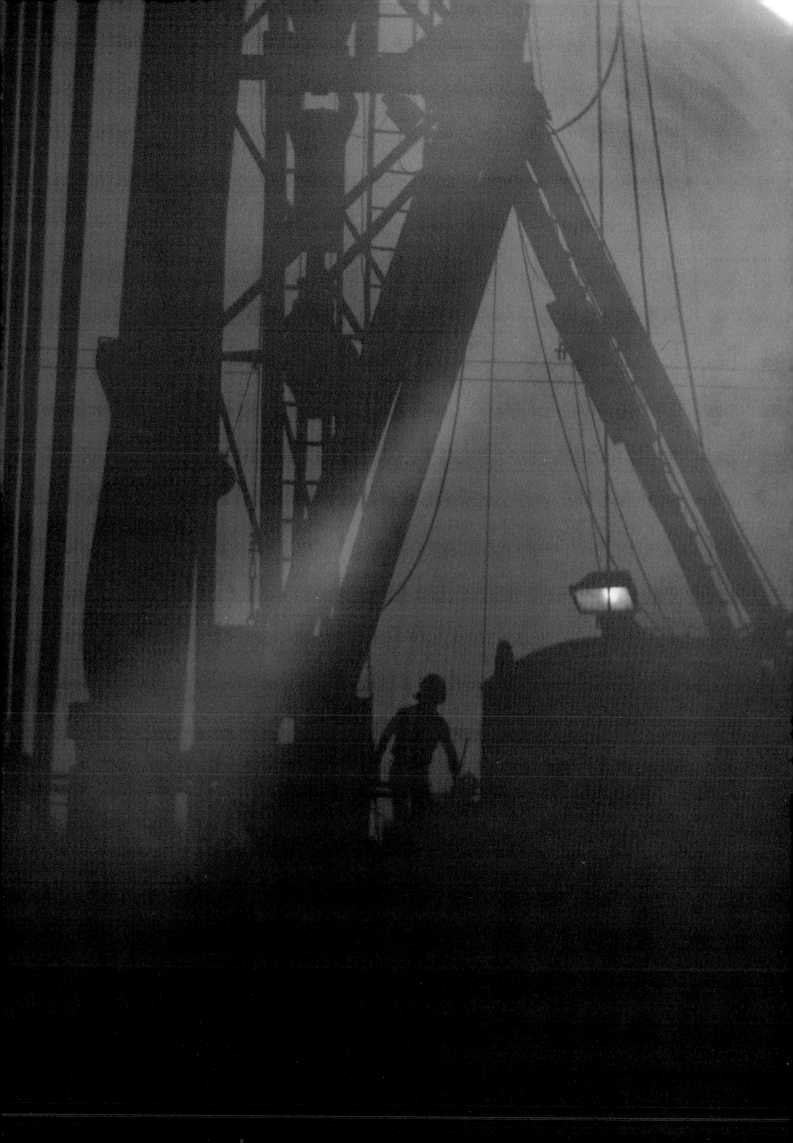

"I told my dad I was gonna join the oil field. He said, 'You're gonna do what?'

'I said I'm gonna join the oilfield.'

He said, 'Like hell you are.'

I said, 'Like hell I ain't.'

He said, 'Well, the day you join the oilfield is the day you move out.'

I said, 'Well, point me to my room, and let me get my bags.' I got my bags and I joined the oilfield."

BERNIE

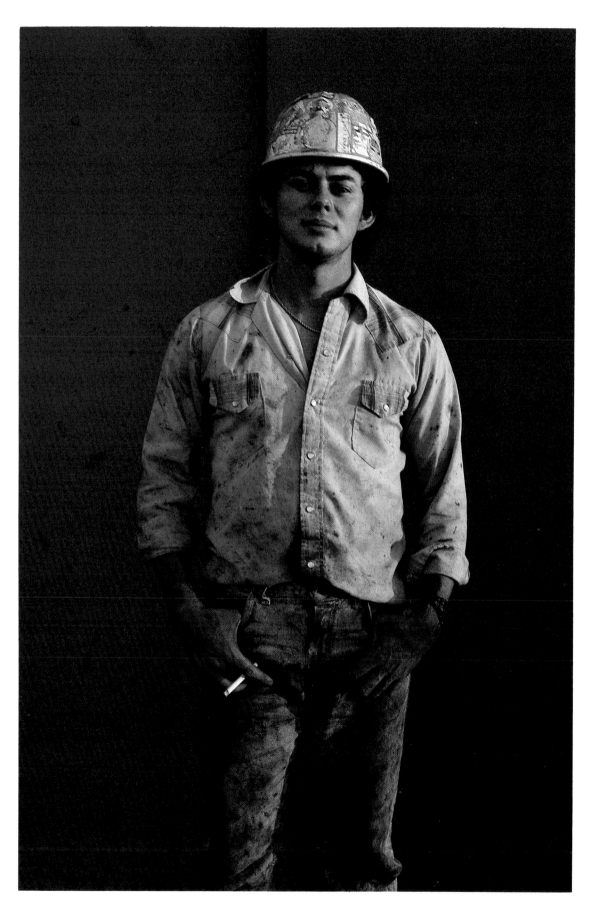

B E R N I E , K A T Y , T E X A S

"I just like the smell of oil. I like the oil-field better than anybody. When I was young you couldn't keep me out of the oilfield."

REX

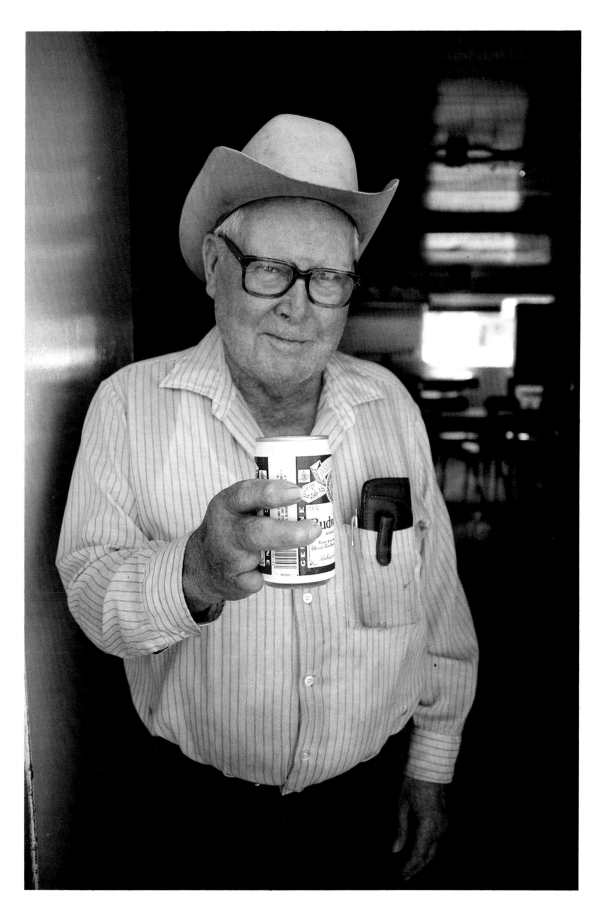

REX, BIG SPRING, TEXAS

"I know it's dangerous out there. I had a seventeen year old friend killed when a rig blew up. He had just got a paper signed by his parents the week before to go offshore. The rig blew up and he drowned. His parents said the Gulf was just waiting to swallow him up."

K O N A W A , O K L A H O M A

"Zachary Carter, the son of Zack and Lola Carter, was born in Shawnee, September the nineteenth, 1952. And passed from this life in Shawnee on July the sixth, 1985, after having attained the age of thirty-two years. Reared in Tecumseh, he was a 1970 graduate of Tecumseh High School. He had worked in the oilfield for the past fifteen years. He was a roughneck and a driller. He was a member of the Assembly of God of Tecumseh. Surviving relatives include: His wife . . . Two daughters . . . Two sons . . . His parents. . . .

No, he wasn't perfect in all of his ways. But folks, I thank God that Jesus Christ came out of love to seek and to save those who are lost, not those who are perfect."

EULOGY FOR A ROUGHNECK

SITE OF ZACHARY'S DEATH, SHAWNEE, OKLAHOMA

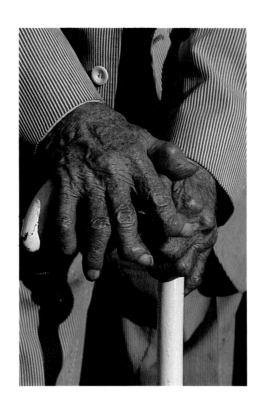

"Spent near my whole life working in the oilfield. First time I worked on a cable tool rig was 1914. Lost the tip of that little finger in 1918. I like the feel of that iron. It's a cooling sensation, unless you lay it down before you run it in the hole. Then it's hot from the sun.

Oh, but it's pleasant. All iron is pleasant."

MEREDITH

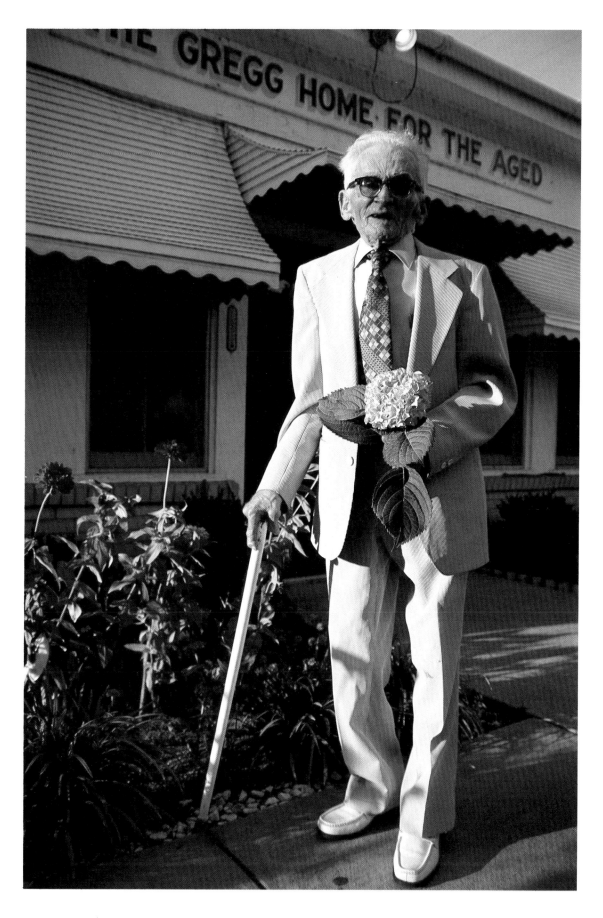

MEREDITH B. TOMLINSON, KILGORE, TEXAS

"You can't be a roughneck after just a year or two years. You can play like you're a roughneck, but when it comes down to it, you need a big heart, a good head, strong arms, and you got to want to work."

ROUGHNECK

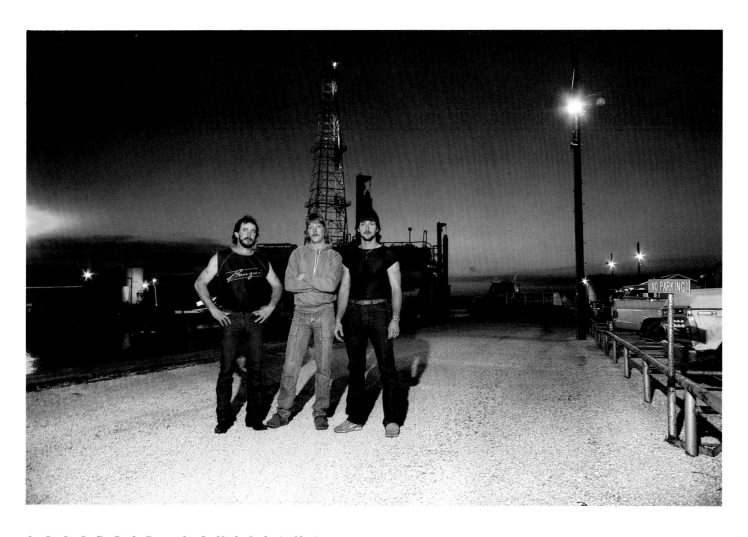

COCODRIE, LOUISIANA

"I'll tell you the onliest thing I like about the oilfield is you go out to the oilfield and you do an honest day's work for an honest dollar. The work is hard. The Bible told me, it says, Hank, a man lives by the sweat of his brow. That's the way I live. I work hard for a dollar."

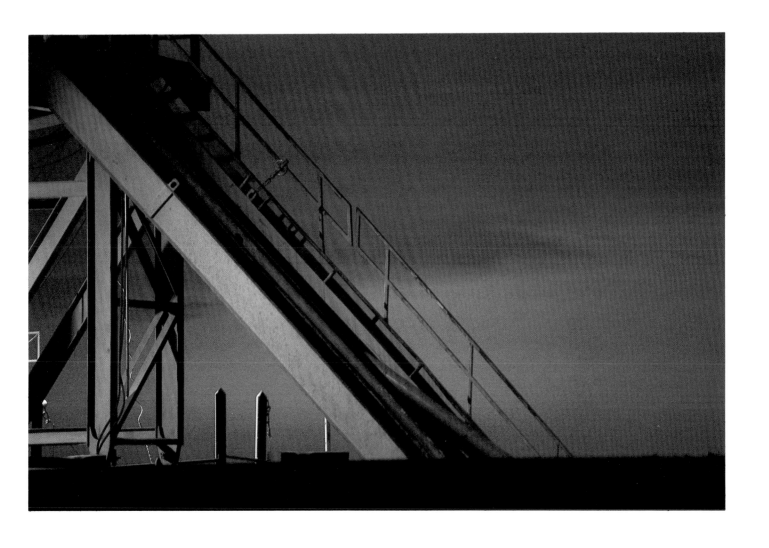

ACKNOWLEDGMENTS

Laurette Angsten and Randall Thropp did far more than simply design the book. Laurie's artistry and enthusiasm informed and energized this work from the beginning. Randy's eye and ability as a storyteller held it together. This book is a collaboration. Their hard work and good humor were in the roughnecking tradition.

At Taylor Publishing, Bobby Frese first proposed turning a camera towards the oil fields, and his unflagging energy and encouragement has kept the work exciting and fun. Kathy Ferguson is responsible for the consistent quality of color reproduction and printing of the book.

In New York, my talented assistant Katherine Bescherer organized and managed the production of the final manuscript, as she does much of my working life. Jess Ford kept order while I was on the road.

Bill Black, a photo editor who is partly responsible for my sticking with photography, Joe Gioia, and Richard Nalley, my partner on many stories, were valued advisers and critics as the work progressed, as were Kevin Cobb, lost to L.A., and Quentin Hardy, lately of London. I am lucky to have such friends.

On the road, Dean Ellis in New Orleans became an old friend in no time, and put me up for months.

Old Woodberry Forest chums kept the road from ever seeming long or cold. They got me oriented to Oilpatch, and provided consistent guidance, regular meals and occasional madness. Thanks to Sam and Marilou Robinson in New Orleans, John and Tee Zimmerman in Lafayette, Will Nixon and Peter Larkin in Austin, Sam Chambers in Houston, Marvin Bush in Washington, Robert Kirk, Mike MacMillan, and Roger Wilson in New York, and Richard King, former roughneck, all over south Texas. Nothing like old friends. . . .

In the early stages, people from several companies went out of their way to help. Especially Brenda Buras at Texaco, Mike Kimmett at Mobil, Al Spindler at Odeco, Kay at Fluor Drilling, Kathy Johnson and Gail Sabanosh at Exxon, Martin Tilson at Sonat, Darrell Jones of Investment Drilling Consultants, Bill Bailey in New Orleans, and the entire crews of the platform rigs Mr. Si and New Orleans, the drillship Seven Seas Discoverer, Questor #3, Penrod #128, and the pilots of Petroleum Helicopters Inc. and Air Logistics.

Special thanks to each of the following:
Ursula Mahoney, Gail Heimann, Amelie Kelly, Jimmy Westerman, Daniel and Willie, Mike Conaway, Larry and Karen Feld, Glenna Foster, Maria Morse, Robert and Laurie Trunchin, Vic Ayad, Phillip Riegel and Rick Buchanan, H. B. Fuqua, William Bagby, Robert Montague, Bob Palmer, Hans Helmerich, October Productions, the Bob Van Allen Studio, the American Petroleum Institute, and Delta, Nicor, Bay and Lance Drilling Companies, Amoco, Shell, the Exploration Company of Louisiana, and the East Texas and Permian Basin Petroleum Museums.

I'd also like to thank all my friends who have hung in there with me during the past year, and Laurie who stuck with me through it all, and my family who has always been supportive of my work: Connie, Mike, Tyler and Cary Neer, and Cary, David and little Ben Williams, and Neal and Ralph Kittle, my parents.

Finally, thanks to everybody who took the time and interest to be photographed and interviewed for this book, especially the people who appear on the preceding pages. They watched out for me on the rigs and in the bars and brothels, and welcomed me into their homes and offices and churches. The people of Oilpatch were very kind to this stranger.

BOOK NOTES

The quotes appearing beneath or opposite photographs in this book were not spoken by the people in the photographs unless specifically attributed to them. All quotes were taken from transcripts of conversations taped or recorded in a notebook. Some quotes have been cleaned up to enhance clarity. We have tried to preserve the intent and language of the original speakers and aspire to good journalism.

The photographs in this book were made with Canon cameras and lenses that ranged from 20mm to 600mm, on Kodachrome 25 and 64 daylight film. No filters were used. Though most of the photographs are presented full frame, some were cropped to fit the space determined by the designers' original concept. Inanimate objects were never manipulated; people were given minimal direction, e.g., "Would you step over here," or "That's fine right where you are."

A limited number of color prints made by the author are available. For information write, ROUGHNECKS, P. O. Box 1764, Madison Square Station, New York, N. Y. 10159.